Teaching Reality TV
Wendy Helsby

Contents

A note on the Resource sheets

Each of the activities is linked to a chapter, as indicated at the beginning of each chapter. However they can also be done on a 'pick and mix' basis and where there are useful connections this is shown. The final activity provides the basis for a controlled test simulation.

The activities are designed to be adapted and made accessible for different abilities with extension activities for more able students.

Chapter 1 Introduction – 'Planned fiction' (Goodwin, 2005)

The popularity of Reality TV (or as it is often known in the industry 'format television') is evident in the number of reality shows that are in the schedules. There will be very few students (if any) who have not viewed *Big Brother*, *The X Factor*, or one of the many other reality shows. The light-hearted approach of these shows is popular with audiences who are also part of the process by being both its stars and its jury. Producers have embraced them in an increasingly stretched multi-media market as they provide a cheap, and if the formula is right, a fool-proof way of attracting audiences.

The form certainly reveals changing social worlds but how far is reality TV a cause or an effect? Its development has been fuelled by new technologies such as lightweight digital cameras, which have offered to the audience an unprecedented *intimacy*, *immediacy* and *interactivity*. But it is the unscripted and the ordinary at peak time viewing which is the remarkable phenomenon, given the history and traditions of television. The central theme of these shows seems to be focused on the individual and their personal identity, a shift from the collective identity previously seen in traditional TV.

For Media Studies this phenomenon of reality television can be viewed from two basic opposing positions. The political-economic view is that it is cheap, exploitative television which does not challenge underlying issues affecting the lives of ordinary people or the structures of society. It has been criticised for skewing factual media content towards entertainment. The exploitation of the celebrities they make, the number of column inches they produce, the chat shows and gossip they generate have been accused of providing audiences with a fake, manipulative and voyeuristic world.

However others, the social-liberal approach, see it as a visible democratisation of the media world. This view states that for audiences reality shows offer an opportunity for interaction and for the participants an individual acknowledgement of their worth and possible celebrity standing, if only briefly. It suggests a new assessment of cultural capital and a new democratic access to the powerful media for non-professionals.

This polarisation of approaches highlights why studying Reality TV can be seen as a way of understanding the media, its power in our society, how it constructs beliefs and values, and therefore why it should be taken as seriously as studying the news or traditional documentaries.

Definitions

⇒Activity 1

Most of us have a common-sense idea of what we understand to be Reality TV. However in order to study the genre there needs to be more than just a common-sense understanding, there needs to be an agreed definition and a methodical approach .

If you look on professional television production websites you will more frequently see the terms 'formatted documentary' or 'format television' or 'entertainment documentary' or 'event TV'; '*Big Brother*, which is a global phenomenon, is an extreme example of this "Event TV"' (Biressi and Nunn, 2005: 11). Reality TV (coined in the 1990s and now a highly contested label) is really an umbrella term for a range of programmes or formats, many of them hybrids. It is also used retrospectively to refer to forms which appeared in the 1980s. These in their turn originated from earlier types of factual programming.

A definition of Reality TV given by Richard Kilborn in 1994 was one or other of the following:

1. Recording 'on the wing' of events in the lives of individuals or groups.

2. The attempt to simulate real-life events through dramatised reconstruction.

3. The incorporation of 1 and 2 in edited form in a packaged programme.
(Gillespie, 2006: 423)

The Oxford University Press's definition is … 'A term for television shows that are based on real people (not actors) in real situations, presented as entertainment'(www.oup.com/elt/catalogue/teach ersites/, accessed 23/05/09).

Notice the shift of emphasis towards entertainment. Today Reality TV covers a variety of programmes including docu-soaps, docu-games/challenges, video diaries, law and order crime formats, emergency services programmes such as *999*, life-style programmes such as makeovers, talent shows as with *The X Factor*, talk shows, viewer camcorder programmes and so on. One of the most successful formats is the game show where people are taken out of their ordinary environment and exposed to challenges, as with *Survivor* (ITV1). At the other end of the entertainment – education spectrum are the historical re-constructions such as *Victorian Farm* (BBC2, 2009) which was listed under both

Introduction

documentary and reality on the BBC website and called an 'historical observational documentary'. In essence this is similar to a docu-game show in that people are transposed to an artificially created environment, have to perform various tasks assigned to them and talk to camera about the experiences, their feeling, adversities and problems but with an educational aim and without the competitive element.

The basic similarity between all these formats, whether educational or entertainment, is that they claim to use ordinary people (possibly), are mainly unscripted and spontaneous (debateable) and that they reveal a reality unmediated by professionals (challengeable).

What Can Studying Reality Television Reveal?

Central to Reality TV is a contradiction between fact and fiction. As Daisy Goodwin, from Channel 4 states, 'The shows I make tend to be *real* people in *real* situations, though *constructed* by us. A pure reality show is a *planned fiction*, a quasi-anthropological experiment. It's precinct TV with people on an island or in a Big Brother container' (my emphasis, Channel 4 Editorial Director Daisy Goodwin, *The Guardian*, 25 July 2001, quoted in Armstrong, 2005 p.116).

The post-modern world and its emphasis on the individual seem to be captured in the Reality TV concept, where the touchstone of achievement is how much celebrity status is acquired. Reality television shows have given access for ordinary people to create ordinary celebrities. They are the constructors of their identity and participants can gain status by merely being themselves. One's 'self' with personal revelations and moments of failure, conflict and success, is shared with many. Personal inhibitions are paraded and challenged and the group responses, against which an individual is set, stand in for the audiences' feelings. The use of video diaries and 'to camera' monologues focuses on this moving boundary between the public and private social spaces. The

tribal nature of constructed reality game shows reminds us of fictional literary experiments such as *Lord of the Flies* (1954, William Golding) and the film *Battle Royale* (2000, Kinji Fukasaku).

One of the key questions to think about therefore when doing work on reality television is whether *Big Brother* or *I'm a Celebrity*, or *Britain Has Talent* with their voyeuristic pleasures also talks to the audience on another level about how we value such things as personal relationships and privacy, and attitudes about the group types represented. The way that these debates can be manipulated for commercial imperatives was highlighted by *The Mail on Sunday* (21 January 2007) after the racism accusation in 2007 in the Big Brother House, which stated 'Fury as "racist" housemate emerges for soft interview with Davina' (they share an agent) and 'swift exit from Channel 4' (there is big money at stake).

These are some of the issues raised by studying Reality TV. The approach adopted here uses four key concepts as the focus, although of course they are inter-dependent. For example in talking about representation in Chapter 7 on debates we are also looking at who has the power to do the representation (industries and institutions); what technical devices are used to do the representation and how the representation fits into generic expectations (textual analysis); as well as how audiences are positioned to read the representation (audiences) and what effect it has on them. We start with the challengeable assumption that there is an identifiable genre which can be termed 'Reality Television'.

In summary the chapters cover the following:

- Text – How are meanings constructed? At the micro level textual analysis includes technical, *mise-en-scène*, visual, verbal and sound languages. At the macro level it looks at how the content is shaped by the narrative structure and how generic conventions help create meaning and expectations for audiences.

- Audiences – How are they created and influenced? This covers areas such as the target

NOTES:

audience for the programme-makers and how they are reached through the use of media language and marketing. It investigates the pleasures audiences gain from these genres and how far they are also part of the production process. As well as how far the media influences the audience.

- Media Institutions and Producers – Why are they popular with producers? This looks at who commissions, produces and screens these shows and why and to what use media institutions put the genre. It asks how far new technology and a changing media-scape influence them and what regulations are in place to control these programmes.

- Debates – What issues are raised? This chapter looks at realism in the media and asks if accuracy and truthfulness are important. It discusses how celebrity culture is used and how it influences society. The debate around representation of groups and stereotyping is raised and also what values and beliefs (ideologies) are being conveyed through these types of show.

Finally a Case Study approach is used to integrate these key concepts on specific texts within various sub-genres of reality television.

This study of Reality TV begins, however, by putting the format into an Historical Context and exploring its roots.

Student Activities

Chapter 1 – Introduction Resource Sheet

Aim: To ensure students understand the parameters within which they are working.

Objectives: To write own definition.

To reflect on this definition having studied the topic

Activity 1 and final review:

- Before studying this topic write down your own definition of Reality TV. Then read the ones given in this chapter. Do these agree with yours or not?

After studying the topic return to this definition. Would you change your original definition? Why? Reflect on what you have learnt about the topic.

Chapter 2 Background to Reality TV – 'Transforming reality' (Corner, 1991)

Having completed this chapter you should be able to:

- Follow the time line which shows how Reality TV evolved.

- Identify the social changes which have contributed to the recent dominance of Reality TV.

- Identify technical elements which have contributed to its style and form.

- Understand why it is called 'Reality' TV.

⇒ Activities 2, 3

In order to understand Reality TV, its conventions and where and how they emerged it is essential to have some sort of historical perspective. This chapter provides the background both for style and form and for understanding the production imperatives and reception by audiences which are discussed in later chapters, focusing on documentary. (N.B.: More information and clips of the documentaries mentioned can be found on the BFI resource site www.screenonline.org.uk.)

The Documentary and Early Beginnings

'Transforming reality' could claim to be the oldest form of the moving image. The first moving pictures were shown by the Lumière Brothers in Paris in December 1895 – although of course film had been developed before then. The first subjects shown to the paying audience were the people around the Lumières who included their factory workers (*Sortie d'usine – Workers leaving the Factory*, 1895) and their family (*Baby's First Meal*, 1895). They also recorded other 'actual' events, such as a train coming into a station and (probably) staged events such as a snowball fight. These actualité short films were the first to be seen by a paying public (for further examples see Mitchell and Keynon's early films, BFI collection 2008; see also other examples on www.screenonline.org.uk) but were soon followed by fictional stories such as *The Gardener* (*L'arroseur arrosé*, 1896, Lumière).

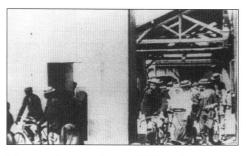

La Sortie des usines Lumière a Lyon (Lumière, 1895), left

However, for some the possibilities of seeing 'reality' and communicating with greater realism events of the world through film (the term documentary was not coined until John Grierson used it in 1926) opened up exciting new possibilities not available to other media. But for audiences it was the fictional films at 'the flickers' which really took their imagination, and pushed forward ideas and techniques in developing narrative. The First World War had opened up opportunities for longer film documents such as *The Battle of the Somme* (1916) which was 80 minutes long, whilst newsreels, such as Pathé news, public service announcements and travel films were an integral part of going to the pictures or movies (see www.bbc.co.uk/history/worldwars/wwone/nonflash_video,shtml accessed 27/03/09).

Later a development of the newsreel in the USA was *The March of Time* which began in 1935. It used both real and dramatised sequences to create a narrative with an editorial stance. It was justified by the head of the *Time* organisation as 'fakery in allegiance to the truth' (in *Citizen Kane*, 1941, Orson Welles famously used this style of newsreel in the opening sequence of the film).

In Russia after the 1917 Revolution a new aesthetic was attempted as the communist ideology wanted to distance itself from Western views because they were dominated by the Hollywood style and American values. It was therefore in Soviet Russia that factual and documentary styles were to flourish and develop as directors used film in radical ways for political, ideological as well as educational purposes. Film-makers like Dziga Vertov (*Man with a Movie Camera*, 1928) wanted to reveal the world through 'revolutionary' eyes and explored new ways of making the population the heroes of the films. Esfir Shub reconstructed the fall of the Czar by re-editing material but giving it a different message to the original intention by adding dramatisation in *The Fall of the Romanov*

Background to Reality TV

Dynasty, 1927. Sergei Eisenstein used a form of montage editing in a powerful way to reveal through juxtaposition and speed of editing political and social statements, for example the juxtaposition of social 'types' in the opening of *Strike* (1925). This was a new proletarian cinema where ordinary people became the 'stars' of the film with directors like Eisenstein frequently using non-actors in their productions.

These films had an influence, both in content and style, on Western film-makers like John Grierson (*The Drifters*, 1929, www.sceenonline.org.uk) who was working for the London Film Society and who helped to edit new inter-titles into Eisenstein's film. (Grierson was to go on to be one of the founding fathers of the British Documentary Movement of the 1930s and 1940s.)

Whilst the Soviet cinema was focusing on ordinary people, in the West another thread to the background of Reality TV was developing. This was the use of the camera to record, for ethnographic purposes, the way of life of indigenous peoples. Robert Flaherty made several films of cultures which had not yet been influenced by the modern world, such as the Inuit people in *Nanook of the North* (1922). These are classics of observation of people's lives. A topic which format television has of course adopted.

Nanook of the North (Flaherty, 1922), right

However because of the limited technology, heavy cameras, poor sound recording (sound only arrived commercially on film in 1927) as well as catching societies on the cusp of leaving their old ways, Flaherty often had to recreate scenes. It was

Grierson in discussing Flaherty's work who first coined the word 'documentary' saying it was 'the creative treatment of actuality'.

This phrase points to an important aspect of any form of factual programming including Reality TV – that is the key concept of 'realism' (see Chapter 7). Suffice to say here that in Media Studies realism involves the issue of how far the mediated images/sounds that we read are a reflection or a construction of the real world. What Grierson's phrase indicates is that even from the very beginning there was an acknowledgement that documentary may not just be about recording what is in front of you, but that it involves choices and therefore interpretation of events.

The British Documentary Movement

The 1930s and 40s were key decades in the development of documentary. In Europe fascism was to use the 'creative treatment of actuality' to support its ideological stance. For example Leni Riefenstahl famously filmed the Nuremburg Rally of 1934 (*Triumph of the Will*, 1935) where in the opening sequence Hitler arrives through the clouds to land god-like amongst his people. It used stylised camera work and lighting to create political meaning within the documentary.

In Britain Grierson had got together a group of talented film-makers including Harry Watt and Humphrey Jennings. They made films like *Night Mail* (Harry Watt and Basil Wright, 1936) which like a docu-soap followed the lives of real people, although here the 'star' was the train. It combined actual footage and recreated scenes such as inside studio-built rail coaches. The strong narrative and the use of poetry (W. H. Auden), music (Benjamin Britten) and sound (Alberto Calvacanti) signalled in Britain the documentary as an aesthetic as well as informational form.

NOTES:

Night Mail (Watt & Wright, 1936), left
© BFI DVD

Another thread in the development of factual film was films with social or political intention such as *Housing Problems* (Edgar Anstey and Arthur Elton, 1935, www.sceenonline.org.uk) which showed the problems of slum dwellers. This involved the first extensive use of direct address by the film's subjects. Later film-makers were to support the war effort with films like *Fires Were Started* (1942), and *Listen to Britain* (1941) in which it is the sounds that tell the story of Britain under attack in a more, poetic indirect address. Many of the people working with Grierson moved into commercial films after the war and heavily influenced the style of the British New Wave in the 1950s and 60s.

New Wave: New Technology

After the Second World War there were several developments both social and technical which changed the face of documentary. Television became the dominant form of domestic entertainment. In Britain a new social order, more equality in educational access for example, led writers and film-makers to discover the working classes as a suitable subject. Free Cinema (www.screenonline.org.uk) in the UK is the name given to a group of film-makers, some of whom had worked with Grierson, who wanted to focus their camera on looking at the lives of ordinary people, such as *We Are the Lambeth Boys* (Karel Reisz, 1959). At the same time the 'Angry Young Men' of the 1950s wrote plays and novels about the issue of class which became films like *Room at the Top* (Jack Clayton, 1959). There was a symbiosis of the topics – everyday life, the style of script and acting – with a new way of filming which created an illusion of realism to be termed social realism.

In Europe film-makers were also looking for ways of changing the traditional forms. Italian neo-realism and the French New Wave movements were the results of these changes. Cinéma-vérité as its name suggests originated in France, particularly with the work of Jean Rouch who like Flaherty was interested in ethnographic research. He would, for example, stop people in the street to ask questions and record their unedited responses. This immediacy and rawness influenced film-makers like Jean-Luc Goddard, Ken Loach and John Cassavetes. On television though factual television appeared to be stuck in the format of the newsreel or information

programmes where a series of interviews and statistics presented the programme-maker's view. This style is sometimes referred to as expositional documentary.

In America the new technology of lightweight cameras led documentary makers carrying the camera into the action; it was taken off the tripod and became mobile. In addition it was now possible to record synchronised sound using magnetic tape with smaller microphones which freed the camera from the sound cables. The new style was famously used in the documentary made about John F. Kennedy's fight for presidential nomination in 1960. Called *Primary* (Albert Maysles and D. A. Pennebaker, 1960) it followed JFK around and captured through the mobility of the camera his vitality and vivacity as a young candidate. A group of documentary film-makers, including Frederick Wiseman, Richard Leacock and D. A. Pennebaker, utilised this technology to develop a form that was called 'direct cinema'. This aimed at apparently unmediated evidence, unscripted observation, with the audience making their own conclusions drawn from the image and sounds. Other terms given to this style include cinema-vérité, observational and fly-on-the-wall. The aim of these documentary makers was to capture moments without staging or scripting as though the viewer was there watching reality. In the UK Roger Graef's name is most usually associated with this style. The traditional style of documentary with voice-over, interviews with participants and expert opinion was rejected in favour of the camera observing (hence observational documentary). They allowed events to develop naturally rather than to construct a pre-conceived narrative. Graef famously 'observed' the police interview of a rape victim which when shown on television was instrumental in getting the police to change the way they treated victims of sexual crime (*Police*, 1982, www.screenonline.org.uk). This new aesthetic also reflected the informality that had developed in post-Second World War society.

1960s Code Mixing – Dramatisation, Reconstruction, Surveillance

Although film was experimenting at the beginning of the 1960s, British television was producing documentaries about current affairs using the classic methods of voice-over (usually male), interviews with experts and/or ordinary people, studio discussions, graphics for statistics, archive footage and other information to back up the argument or position, usually about a single issue. The camera work was often static, carefully framed, interviewees frequently positioned direct

to camera, editing was linear to clarify the cause and effect argument. Previous research had found the witnesses, the locations, the background information and expert opinions and developed the thesis before filming took place. As the influence of the new wave, new technology and changing social mores took hold television began to develop its own 'voice'. *Panorama* and *World in Action* (e.g. *Death on the Rock* ITV, Roger Bolton, 1988) were instrumental in investigating contemporary issues and challenged the status quo. One technique was to use 'vox pop' – i.e. 'the voice of the people' – to add a sense of reality to the topic. This technique was also sometimes used when ordinary people were allowed to make a programme on a subject they felt strongly about, rather like a soap-box. These were called Public Access programmes, one such was *Open Door*.

However in terms of style and form it was the drama-documentary on television that really caused the most important shift and furore during the 1960s and 70s. One of the most famous of these was *Cathy Come Home* (BBC 1966, www.screenonline.org.uk) produced by Ken Loach and Tony Garnett, both of whom were left-wing/socialist in their outlooks. What they did was to combine the factual style of documentary by using the accessed voices of people, voice-over, moving camera work and statistics, with the fictional style of a narrative about a young family forced into homelessness and the subsequent break-up of the family. They used elements which are now common to a docu-soap such as rapid cutting between scenes, unsteady camera, framing off balance, no sustained point of view, moving cameras.

Cathy Come Home (Loach, 1966), right

This style continued in drama with programmes

such as BBC's *Cops* (1998–2000) and *Attachments* (2000) both coming from Tony Garnett's company. These were fictional stories taking on documentary conventions; a trend which had been started in police shows such as *Z Cars* (BBC, 1962–78) and later *NYPD Blues* (1993–2005) which also used hand-held cameras, awkward framing, over-lapping sound to simulate reality. So the force of the fictional narrative is underpinned by the reality conveyed through the documentary techniques. *Cathy* certainly contributed powerfully to the debate on housing policy and homelessness that was on-going at the time.

This style, which spawned several other similar programmes, became the centre for political controversy as politicians claimed that audiences were being manipulated and deceived into thinking they were watching real events by the mixing of the tele-visual codes of drama and documentary. *The War Game* (Peter Watkins, 1965, www.screenonline.org.uk) was one such extreme example. Made for a drama slot on BBC television to be shown on the anniversary (August 1966) of Hiroshima it was based upon government reports of the effects of a nuclear bomb and made substantial use of a documentary style of voice-over. It was not shown until 1985 although it ironically won an Academy Award for the best documentary in 1966.

Another aspect of documentary making is that many events cannot be captured by a camera so a documentary producer may want to re-construct events to develop their point, as with *Hillsborough* (1996, www.screenonline.org.uk) which was a reconstruction of the football stadium disaster. Such programmes are often used to explore recent events like the death of Diana, Princess of Wales and the last days in office of Margaret Thatcher (BBC2, 2009). However they are often more reconstructions with obvious dramatic licence and do not necessarily incur the wrath of politicians that the earlier drama-documentaries did. Additionally perhaps audiences are more able to identify and read such combinations of codes

NOTES:

and are less 'shocked' by their effects.

Another thread which would influence some reality TV was the use of hidden cameras. In these programmes unsuspecting people could be set-up as in *Candid Camera* (ITV, 1960–6), or viewers send in clips usually based on embarrassing or funny moments as with *You've Been Framed* (ITV, 1990–present). The internet with U-Tube has exponentially increased the number of such types of home recording available for viewer consumption.

1970s and the Fly

Most significantly for Reality TV the 1970s saw the development of the fly-on-the-wall technique raised to a new level on British television. In Paul Watson's series *The Family* (1974) a Reading family was followed by television cameras as they went about their normal lives. The cameras were left running and many of the intimate moments of family life were recorded. This programme 'shocked' the nation. Many were critical of the way it revealed the interaction and values of a working-class family. It was so controversial that the initial showing had sociologists and other experts 'interpreting' the programmes for the viewers therefore validating it as educational or a social document. What was significant in terms of Reality TV as well as the filming techniques was the way it made the mother of the family, who was a dominant matriarchal figure, well known to the public. I hesitate to use the word 'celebrity' because of its current connotations, but Margaret Wilkins was certainly a recognisable face after her appearance in *The Family*. The programmes were shown as a serial with each episode giving a summary of events so far. For these reasons it is sometimes referred to as the first docu-soap (www.screenonline.org.uk).

Watson went on to repeat this experiment in Australia with *Sylvania Waters* (1992). Watson was again the centre of controversy as the mother in this family criticised him for his editing of the material which, for example, juxtaposed her, apparently uncaring, at the hairdressers whilst her daughter was in hospital giving birth.

Observational 1980s Style

One effect of new video technology in the 1980s was that film-makers were able to have smaller crews and therefore get into new situations: documentary makers like Molly Dineen in *The Ark* (1993) which she made about London Zoo where she became an 'unacknowledged watcher' (Lawson, 1993) and Nick Broomfield who also began to become the 'star' in his own production fore-fronting the devices of construction such as

microphones and cameras (see for example Broomfield's *The Leader, The Driver, The Driver's Wife*, 1987 and *Aileen: Life and Death of a Serial Killer*, 2003). In *The Thin Blue Line* (1988) Errol Morris similarly used new techniques to reveal the process in an investigation into the wrongful arrest of a man for murder. These are often referred to as 'authored' documentaries.

During the 1980s new technology became domestically available and ordinary people were able to produce relatively cheaply their own versions of Lumière actualities. The video recorder also gave the first opportunity for the camera to get into the hands of the public to produce something that was not just for domestic consumption. For example in *One Day in the Life of Television* (ITV, 1989) which documented 24 hours of television much of it was filmed by ordinary people recording what they were doing with television. A third area was television shows using footage from the public, out-takes of programmes or set-ups which used surveillance camera techniques. These were personal views or anecdotes, but they still needed the large media institutions to be seen. Today the question of access to expensive broadcasting time has been sidestepped by the Internet with on-line diarists and twitterers providing personal points of view for others to consume.

1990s Digital

By the 1990s new technology such as lightweight digital cameras, better lenses which enabled shooting in natural light and the ability to record synchronised sound with radio voice mikes, opened up possibilities for recording and editing with shorter access times for broadcasters and for the general public to be able to produce their own 'creative treatment of actuality'. The first real venture into this area was the BBC's *Video Diaries* (1993) and *Video Nation* (BBC2, 1995). These short 'interlude' programmes enabled ordinary people both in the UK and around the world to produce, after minimal training and with editorial support, their own document. *Video Diaries* and *Video Nation* were a combination of the mass observation studies done in the 1930s, where people had kept written diaries for anthropological studies and documentary entertainment. These short pieces showed that ordinary people could be both the producers, who had something significant to say, and the subject of the programmes, who resonated with the audience and with whom the audience identified. This was a sea-change in the way that television as a one way communicator had previously been conceived. The viewing figures showed the popularity of these very low-key series and opened up the possibility of longer versions of people's lives being of interest to

Background to Reality TV

audiences.

An attempt at recording a real-life soap was made with *The Living Soap* (BBC 2, 1994) using the fly-on-the-wall techniques. A group of volunteer Manchester students were selected and filmed living together in a student house. With any new form naming becomes a significant factor. 'We don't call it fly-on-the wall now,' said a BBC spokeswoman. 'It's a cross between a soap opera and a documentary, so the word is soapymentary, or docusoap' (Michael Leapman, *The Independent*, 24 August 1993). It was of course docu-soap which stuck. A similar programme was Channel 4's *Flatmates* (2000).

Another strand developed as a response to this new technology was the institutional documentary about working places, such as *Children's Hospital*, based on Great Ormond Street hospital in London and surveillance shows, such as ITV's *Police, Camera, Action* (first broadcast in 1994 now labelled 'extreme reality')

In the world of the professional TV programme-maker the fact that these people were of interest to the viewing public showed them the potential for making documents based around the everyday, but with an on-going rather than one-off scheduling normal for documentaries. They were termed docu-soaps both because of their on-going episodes and their style and content.

So the period 1995–7 was the real beginning of the docu-soap where the personalities became more important than the institutions. A series of shows appeared such as *Airport* (BBC2, 1996) through which a BAA employee Jeremy Spake became a celebrity (he went on to appear in *Blankety Blank*). Another was *Driving School* (1997, BBC 1, see also www.screenonline.org.uk). The 'star' of *Driving School* was Maureen a learner driver who had failed her test on multiple occasions. The popularity of these shows and the celebrity status accorded to some of the participants encouraged more to follow including *The Cruise* (BBC1, 1997), which made a star of Jane McDonald, and

Hotel (BBC 1 1997) which was based on the Adelphi Hotel, Liverpool and from which a record and a 20 percent rise in bookings at the hotel resulted.

At the same time as the docu-soap, other threads of documenting lives were being developed. These were the life-style programmes and makeovers such as of gardens (*Ground Force* BBC1, 1997) and homes (*Changing Rooms*, 1996) as well as fashion (*What Not to Wear* BBC1, 2001). The next big step was the *Big Brother* phenomenon of 2000 where people were put into an artificial rather than real situation to be observed by cameras.

All of these types of show can still be found today in the television schedules.

2000 Onwards: Big Brother and Reality Talent Shows

With *Big Brother* and *Survivor* and their specially built locations 'we have moved towards a "fly-IN-the-wall documentary"' (www.mediaknowall.com/documentary/reality.html, accessed 11/03/2009). These were a combination of game shows and documentaries and so were termed docu-game. Another trend was the talent shows. Unlike previous talent shows the processes by which the 'talent' was picked and developed were part of the entertainment. *Strictly Come Dancing* (BBC); *The X Factor*, (ITV), *Dancing on Ice* (ITV), and the search for stars of musical theatre with Andrew Lloyd Webber's *Sound of Music* (Maria) and *Oliver* (Oliver and Nancy) are just some examples; others are cookery and gardening programmes.

Audiences understand that there are different types of factual programming from the news to magazine programmes and documentaries which can be expositional, observational, participatory, reflexive and poetic. The relationship between television texts, the real world and audiences is dependent upon how that world is re-presented.

NOTES:

With all these shows, even the fly-on-the-wall, there are the crew members and equipment around and visible to the participants.

All of these new reality shows depend upon willing volunteers and new formats, the money and the technology (the red button), the Internet, the producers and of course you the audience. The common denominator is that they all have some claim to being about 'reality'. The question is whether the video diary format and its descendents have really altered the hierarchy within television and the broader media.

Student Activities

Chapter 2 – Background to Reality TV Resources

Activity 2a – Development of Documentary Styles

Aim: To understand that codes and conventions of a genre change and develop because of historical and contextual factors.

Objectives: To establish differences in documentary styles.

To see how documentaries have developed over time.

To understand the codes and conventions of a documentary.

↘ Teacher: Prepare a range of documentary clips from different decades. Show in non-chronological order:

- Ask paired students to put them in the right chronological order. Feedback in groups
- Discuss and note the reasons for their order.
- Compare notes with other groups.
- Come up with an agreed order.
- How far is this the correct order?
- Discuss the codes of documentary and how they have changed.

Extension Activity: Discuss: What are the main differences that you see between the different decades? Why do you think these differences occurred? (Consider style, content, technology, participants, mode of address to audience.)

Activity 2b insert timeline

Draw a timeline from 1895 to 2010 and indicate the key developments in factual texts along it, e.g.

1895 1920s 1930s 1940s 1950s, etc.

Actuality films Soviet cinema

Student Activities

Activity 3a – Conventions of a Documentary – Resources

Aim: To use textual analysis to deconstruct a documentary.

Objectives: To compare factual programming with Reality TV – see 3b.

↘ Teacher: Select an extract from any classic expositional documentary.

Show the extract and ask students to observe its conventions:

- Does the presenter appear visually?
- Does the presenter or the voice over try to persuade you to a particular view point e.g. about the people in the programme?
- What style of language is used? Is it matter-of-fact or emotive? Is it scripted or rehearsed? Is it informal/formal?
- What types of people are the 'stars' of the show?- ordinary, everyday, bizarre, quirky, talkative, do you feel they are stereotypes?
- How are the 'characters' presented? What does the camera position suggest about them?
- Are they seen always in their real life or are they interviewed in another space?
- What visual effects are used and why? (e.g. hiding identities)?
- Do you notice any particular editing techniques, such as juxtaposition of images or actions?
- What technical codes are used such as lighting, colour, camera angles and framing?
- Are any graphics used?
- Is found footage; archive material used?

Activity 3b – Comparison of Documentary and Docu-soap

- ↘ Teacher: Prepare two extracts, one used in 3a and one from a current docu-soap:
- Watch a short extract from an expository documentary and one from a docu-soap.
- Using a different colour for each show, tick elements from the list below as you see them.

Elements	Documentary title	Docu-soap title
Presenter in view		
Presenter as voice-over		
Steady camera		
Moving/unsteady camera		
Careful framing		
Framing not controlled		
Logical argument developed		
Bias/point of view evident		
Found/archive/library footage used		
Scripted/rehearsed		
Apparent lack of script		
Ordered events		
Non-diegetic sound track		
Ordinary people		
Expert witnesses		
Inform, educate		
Privileged view (fly) of intimate details of lives		
Voyeuristic		
Direct address to camera – such as a diary room		
Unpredictable narrative		
Editing juxtaposition		

Extension Activity: Look at your results. Note any significant conclusions – the use of different colours should help you spot points. Write a short essay entitled 'Compare and Contrast the Documentary and Reality Show Codes and Conventions'.

Genre

Chapter 3 Genre – 'A new authenticity' (Keighron, 1993)

Having completed this chapter you should be able to:

- Identify some of the elements of different types of reality show.

- Understand how the genre has developed and changed, and its cycle.

- Be able to link elements to past styles to show continuities and change.

- Realise that a name is only a convenience label and understanding what is identified by that label is a complex issue.

⇒ Activities 4 – 6

⇒ Activity 23b *The Truman Show*

General Introduction

Genre (a French word meaning type) consists of formal characteristic patterns and signs which cross individual texts. Codes and conventions are the accepted characteristics for a particular genre, such as the topic being about real people in a documentary and not fictionalised characters. However conventions can be stretched and changed, an on-going process. Genres traditionally have been described as going through several stages; the experiment, the classic, the parody, the self-reflexive and finally the decline. For example the docu-soap could be divided into the experimental with the fly-on-the-wall *The Family*; the classic, *The Cruise*; the parody, *The Office*. They can renew themselves and join together a form of in-breeding (Staiger, 2003) more commonly known as a hybrid form. Wikipedia, the online encyclopaedia lists the following reality formats: documentary style, elimination/game show, self-improvement/makeover, renovation, social experiment, dating shows, talk shows, hidden cameras, supernatural and hoaxes. So Reality TV is essentially an umbrella term for different types of programming.

Genres operate not only as a means of recognising the types of text and the iconic elements but also as a social discourse. This means that rather than spot typical locations, clothes and/or objects, the question to ask of a text is: what is the dominant organising theme? This signals how a particular genre positions the audience into a way of reading by its mode of address.

It is difficult to try to find a single formula or organising theme for Reality TV. For example, what is its purpose – to inform, to educate, to entertain? Perhaps one way of approaching the genre is to see Reality TV as a post-modern response to contemporary culture which delivers a focus on the ordinary individual and scepticism about the reliance on experts and professionals.

And despite the diversity of Reality TV there is commonality of being rooted in factual programming using ordinary/real people 'playing' themselves.

The Factual Base and Dramatic Exposition

Reality TV comes from the fly-on-the-wall and observational end of the spectrum of factual programming. This style is combined with dramatic events in a reverse of the drama-documentary that began in the 1960s. Caughie (1980) lists the way that drama-documentary relies upon the documentary style of apparently unrehearsed events, hand-held camera movements, out of focus, poor framing and overlapping sound which provides it with the feeling of authenticity; whilst the dramatic conventions rely upon hiding the devices through continuity editing, careful framing and rehearsing. Both styles of documentary and drama can be seen in Reality TV.

NOTES:

The Aesthetics of Reality TV

Although Reality TV does cover many different types of programme there are some similarities in terms of style and conventions and the way it selects, edits, reconstructs and is the 'fly-on-the-wall'. It may for example have an off-screen interviewer to whom the participant replies, combining observational style with commentary from the participants. It also has some game-show elements and construction of personality all captured 'at the moment' – or so it seems.

Reality TV is about shooting material after a preparation period in which characters who may become 'personalities' are identified. The action however has to follow what emerges rather than be pre-planned for editing. So in *The Hospital* (2008) when a staff nurse was being interviewed about her role and her emergency bleeper went off she had to run to the resuscitation unit and the interview stopped, but the camera followed her. Reality TV therefore has an affinity with drama and dramatic action if, unlike drama, it is un-staged. This allows television to show two of its most useful characteristics as a medium: intimacy and immediacy.

Intimacy is conveyed through framing and other confessional/reflection scenes. One of the most important elements in filming drama for television is the use of the close-up and two shot. They are extremely common in soaps as they bring us intimately into contact with the characters. Reality TV has adopted this style. Viewers are positioned to identify with the personalities who appear and are shown both their strengths and their weaknesses in close-up, particularly when talking to camera.

Immediacy is conveyed through un-staged events and conventions such as graphics, dates, times and locations. This technique is often seen where events are unfolding rapidly as in a police or hospital environment. It also connotes the style of a report that the participants, such as police or medics, will be making on the events as part of their working lives and underlines the 'reality' of the scene. Immediacy is of course very real when seen through the Internet in something like *Big Brother* where events are streamed continuously in (almost) real time. This suggests less control of events. Of course even in *Big Brother* there is always an element of construction as choices of camera, editing, angles and so on have to be made. Even with Direct Cinema (see Chapter 2), when there was no staging there had to be a choice for the 'camera-eye' so the documentary maker could not help but set an agenda.

The Use of Personalities

For some reality shows there is an audition process and a selection made by producers which obviously suggest that the participants are chosen to play to particular types, such as the dizzy blonde or the 'lad'. On docu-games these types are often quite evident. Less obvious casting is when a real location is adopted. Even here the focus moves onto people who are charismatic, loquacious and 'larger than life'. The range of characters in a programme also allows the audience to identify with either the quieter personas or those who put on more display:

> 'All the programme makers agree that it is impossible to come up with an identikit for a successful star of docusoaps … "you have to get a mixture of people who provoke and evoke a range of emotions. That's the key."' (Mills, BBC executive producer, in Ogle, 1998: 24)

Celebrities of course already bring a media persona to which the audience is attuned. There is then an elision between the ordinary and celebrity groups. Participants represent 'us', ordinary people like the viewers doing 'ordinary' jobs. But by being on television they have also become celebrities to be recognised in the streets and some (not only those in talent shows) go on to have other careers in the media, such as Jane McDonald in *The Cruise* and Jeremy in *Airport*. Jane was a cruise ship singer and she used her exposure on the docu-soap to forward her professional career. A recent article in an in-flight magazine reminded the reader that she 'starred in BBC1's *The Cruise* ….Britain's best-loved docu-soap diva' ('Cruising – It's the Only Way to Travel', *Imagine* 4 (2009): 16–17, TUI UK & Ireland). Notice the use of 'starred' as a description – even though Jane was only one of many workers on the ship. Other celebrities have been created by docu-games such as Jade Goody. Here the line between 'ordinary' and 'celebrity' is shown to be capable of being crossed even without a specific talent.

How do the participants feel about their exposure? Obviously some find it quite a tough experience but others welcome their 'fifteen minutes of fame' (Warhol). Maureen Rees from *Driving School* (BBC 1) who took seven attempts to pass her test said, 'I could die tomorrow and I'd be happy because no one can take your memories away' and Jeremy Spake, Aeroflot traffic supervisor who appeared in *Airport* (BBC 1) said, 'I even had two women from the south coast who wanted to start a fan club' (Ogle, 1998). There is of course the downside to fame. Maureen for example had one hate mail letter saying, 'You're a fat ugly cow, you shouldn't be on television. You had cancer nine years ago and I hope you get it again and it kills you…' Several

Genre

participants in reality shows have suffered as a result of their exposure on television even to the extent of suicide; one such was Paula Goddard in the USA a participant in a talent show who committed suicide outside one of the judge's homes (Adams, *The Independent*, 6 July 2009). Susan Boyle, having been built up as the favourite in *Britain's Got Talent* 2009, suffered mentally when she came second.

What makes a docu-star? 'Olivia Lichenstein, series editor of *Inside Story* and executive producer of *The Cruise* believes it boils down to being unselfconscious, "It's a willingness to be themselves and an ability to say, 'This is me, warts and all, like it or lump it.' Without that being arrogance"' (Ogle, 1998: 24).

How could you become a docu-soap star?

• Presence – stick out in a crowd.

• A bit of a show-off – someone who is going to be relaxed and a performer.

• Openness – being expansive.

• Does not care about what people think – not necessarily sympathetic.

The participants are also chosen so that they help to create a story. As the audience watch they can see the narrative roles of a drama being taken up by the participants and identify the hero, the villain, the helper and others which add to the narrative characteristics whether in a soap or a game (see Chapter 4).

Sub-genres of Reality Television

As we have already seen there are many variations of reality shows, here the main categories to be considered are: personal diaries; docu-soap; formatted documentary; docu-game; education; makeovers; surveillance; extreme reality.

Video Diaries

This style was one of the earliest forms of Reality

TV built on the access programmes of the 1970s such as *Open Door*:

• They had the aesthetics of realism with shaky footage, use of auto-focus, lighting glitches, and therefore connoted integrity (i.e. this was really real) or 'a new authenticity' (Keighron, 1993).

• The cheapness of the product meant that quite a lot of the research was done 'on the hoof' as unlike expensive film, video meant you could cheaply delete useless footage.

• The maker and subject of the diary took on all the roles normally undertaken by professionals within a documentary although the important decisions were still taken for television by the professionals, such as who was chosen to do a diary. An important question to ask is on what criteria the producers based their choices and what values were in operation when making these choices.

• Today this form has developed on the Internet through blogs and other forms of personal life sharing. These allow for more democratic access to the media for the diary format.

• The aesthetics include first person point of view, a personal agenda, amateur footage, natural lighting and a 'bedroom' confessional approach.

Docu-soap

'Docusoap combines the observation and interpretation of reality in documentary with the continuing character-centred narrative of soap-opera structured by performance and narrative.' (Bignell, 2005)

This form which combines stories about real people with a soap opera narrative style exploded onto British television in the mid-1990s. As with all genres they developed out of experimenting with different codes and conventions of other types, such as the video diary and fly-on-the-wall documentaries (such as *The Family*, see Chapter 2). By the end of the 1990s their format was so well established into a classic form that it was

NOTES:

possible for a spoof to be made in 2001, *The Office*. The sub-genre has continued to develop, for example using the reflective scene (common in reality game shows) where participants comment on their actions.

In the 1990s docu-soaps were extremely popular shows. ITV even moved *London's Burning* to a different schedule when its docu-soap *Airport* (1996) attracted a 50 percent average audience share (Bignell, 2005). Whilst *Driving School* (1997, BBC1) peaked at 12 million viewers, twice as many as *The Bill* against which it was scheduled. The 'star' of *Driving School* was Maureen who had had real difficulty in passing her test. The narrative structure with crisis, turning points, conflicts of her trials and tribulations were as familiar to audiences as any in the contemporary soaps even though these were not fictional characters.

There were various criticisms made of this new format such as of 'faking'. For example a scene of Maureen waking up her husband in the middle of the night to discuss her driving was a re-enactment of something that had happened but obviously cameras were not present to record it. The choice of subjects who were 'over the top' and 'performed' was another criticism of these early docu-soaps. And many media commentators felt that the neutrality of documentary was being compromised.

But the success of the programme based upon the combination of real people and soap codes with its mixture of documentary and drama, immediacy and intimacy was a combination to be repeated. For example in 1998 a *Radio Times* article (Ogle, 1998) looking forward to future docu-soaps on the BBC listed *Pleasure Beach* in Blackpool, *Premier Passions* Sunderland Football squad, *Lion Country* at Longleat, *Superstore* on Tesco, *Doctors' Orders* observing GPs, one on a ski resort, another on Selfridges department store and one on Lakeside shopping mall, whilst zoo keepers at Paignton Zoo, traffic wardens and wheel clampers were also going to feature. I make that eleven shows in one year, just on the BBC.

Aesthetics of docu-soaps:

- Rapid cutting between scenes.

- Charismatic characters to maintain audience interest.

- Conventions of observational documentary such as unsteady hand-held camera.

- Framing off balance creating immediacy, apparently unedited.

- Editing done to create moments of drama, comedy and to provide entertainment.

- Observing actuality, i.e. real life, and intimacy.

- No sustained point of view.

Finding characters that are compelling is important. But just pointing a camera at a personality is not the end of the process for the producer. Building a relationship with the people taking part, getting the right footage, using editing to tell the story in an interesting and entertaining way and moving the format forward so that it does not become formulaic are all part of the producer's role.

There are other deeper structural elements which also help to constitute a docu-soap.

Docu-soaps recognise the documentary film-maker by the subject talking to the camera or answering questions, so acknowledging that it is structured by an outsider even if events as they unfold are unstructured:

- A small group or individual becomes representative for a larger social group (metonymy) such as a group of health workers representing the NHS. This implicitly suggests that the docu-soap is representing reality.

- But to make it entertaining it has to have drama and so conflicts are used to develop dramatic moments. Docu-soaps not only use both melodramatic devices but also the interwoven narrative form of soaps and serials, such as moving from one mini-narrative to another. In a hospital the stories of the patients and the professionals would be interwoven and developed in parallel. These can be juxtaposed depending upon the (melo)dramatic purpose. For example, in an episode in *Airport* a 'stowaway' animal narrative was juxtaposed with that of an illegal immigrant. A convention is then to tell you the outcome of the stories so that there is eventual closure of each individual narrative. In this way it uses the enigma, development, closure format of a classic narrative (Todorov). Sometimes the narratives are not closed in the one episode but continued with a 'hook' and overlapped across the next episodes. This also adds to the reality effect (see Chapter 7).

The conventions of docu-soap were parodied in the situation comedy, *The Office* (2001), '…with its unsettling blend of "reality" TV and comedy … It combines reflexive elements, ironic distancing devices and "fly-on-the-wall", documentary realism' (Branston, 2006: 62). The moving camera travelled through the office space in a documentary style whilst the framing of characters was obscured by such things as filing cabinets or computers. The expected scripted performance of a sitcom was not as evident in the speech patterns and there was no audience laughter, canned or studio. However the

Genre

acceptance that the characters were being filmed allowed them to 'perform'. This is how the David Brent character who talks to camera and often glances at it as if being interviewed, lampoons the reality shows and underlines the weaknesses of the docu-soap and its celebritisation of ordinary individuals. The manipulation of reality, for particular ends whether fame or entertainment points to another issue – that of truthfulness (see Chapter 7).

The 'Formatted Documentary'

Jeremy Mills (in Collins, 2000) used the phrase 'constructed formatted documentary' which identified the next stage in the development of the docu-soap:

- Here people were put into artificial rather than natural surroundings and their lives were observed. The format has one major difference to the original docu-soap in that it suggests a social, such as a makeover, or historical experiment. The experience is created for the benefit of the cameras rather than happening spontaneously.

- This version is defined by the way it edits high-lights of the lives observed such as with *Castaway 2000*: "It's axiomatic that an experiment is going on", says Charles Hunter, executive producer at Watchmaker Productions. "What's attractive for a programme maker is that you get to choose the set, the options, the plot, and make some of the rules. It's getting close to drama"' (Collins, 2000).

- Another example is the 'swap' reality show where life-styles are swapped as with *Wife Swap* or positions are swapped such as with the boss, or a millionaire becoming a down-and-out. These are seen as experiments with human behaviour with a carefully selected group, controlled conditions, setting up of scenarios and recording the reactions of 'real' people.

The *Big Brother* House, far right

Docu-game

The television game show or 'game-doc' such as *Big Brother* (C4, 2000-10) is one of the most successful formats in the reality camp. At one level *Big Brother* is a game show between contestants as in *Deal or No Deal*, and like this show is studio based in an artificial environment rather than in real locations. At another level it claims to be 'reality' by putting the contestants in real life situations in which they are observed, rather like a laboratory research experiment:

- A group of contestants drawn from the public or celebrity cohort compete for a prize.

- Periodically challenges are thrown in and the contestants are rewarded or penalised. This alleviates the boredom for both contestants and audience because 24-hour incarceration and observation can be very boring. (In *The Royle Family*, BBC1, the sitcom family are kept sitting in front of their television and this suggests as well as parodying the lack of action in the life of the ordinary television viewer implicitly commenting upon television audiences such as of *Big Brother*.)

- The series of the docu-game are limited so that a winner emerges having survived being voted off by the audience. This provides another essential element of reality television, interactivity.

- Even though *Big Brother* is a studio show the set is called 'the House' and it combines the observation of social interaction as is done

NOTES:

with fly-on-the-wall documentary with game elements.

- Drama is created by the 'games' combined with a live audience at the location to boo and cheer for each eviction.

- There is a studio commentary which you might find in a sports programme, so emphasising its game element. There is another similarity with a sports programme and that is the multi-camera perspective.

Survivor, a game-doc, was filmed on location not in a studio. It was set up as a contest and was more military survival game connoted by their military clothing than a tourism adventure. The contestants were again seen as experimental participants for the audience to observe. In *I'm a Celebrity…* the participants are watched for the way in which their ordinariness appears through their celebrity personas as they are put under stress. The audience can then feel that the line between ordinary and celebrity is crossable, in both directions.

Living History – Reality TV as Education

The ability to observe ordinary people and its popularity have been taken up by the history departments of broadcasting. There have been a series of participants being put into the living conditions of previous decades such as *The 1940s House* (C4, 2001) to experience/endure their life-styles. A similar show put a group into a *Victorian Farm* (BBC2, 2009) for a year; although this was categorised by the BBC as an 'historical observational documentary' it still came under the reality umbrella (www.bbc.co.uk/programmes/b00gn2bl, accessed 01/04/2009):

- These programmes fulfilled the public service remit for both Channel 4 and the BBC but did it in a way to link with docu-soaps and their popularity by drawing on the personal relations of the participants.

- The first of this type of programme in the UK was *The 1900 House* (C4, 1999). It drew on the re-enactment popular in history programmes but instead of taking specific events it focused on the everyday. But like a reality game show it set up challenges for the participants and allowed the narrative development to be freer than a true re-enactment.

- The narrative voice bridged the gap between the viewers' experiences and the participants to allow us to judge their actions. The voice-over also provided some of the contextual information required to understand the actions of the participants.

- Additional historical material was available on websites as well as games, books and DVDs.

- In some of these types of show we saw the participants doing their own makeovers to convert themselves into their new roles, such as a butler or a female farm worker so adding another element of the reality show to the documentary.

Makeovers

The type of address to audiences for these shows suggests a particular view of perfection. The assumption is that people can be changed by the intervention of a Reality TV show with a fashion makeover (*Gok's Fashion Fix*, C4, 2009–), a house makeover (*Changing Rooms*, ITV, 2004), a garden makeover (*Ground Force*, BBC1, 1997–2005), small businesses from failing to success (*Mary Queen of Shops*, BBC2, 2007–) and more fundamentally, behaviour makeovers (*Super Nanny*, C4, 2004–).

- The makeover show takes one area of our lives and parachutes in experts in the field to transform that area into a successful shop, beautiful garden or give a fashionable look to a previously dowdy individual or change behaviour.

- The audience is told what the key areas are for improvement and how to do it. It therefore becomes a hybrid between a DIY show or garden show for example and the life-style articles common in magazines, particularly women's magazines, of providing a 'new look' or new behaviour. The key to this as a reality show is that these are real people who are being madeover.

- The shows usually start with a disaster area and at the end of half-an-hour or a series, there has been a miraculous change as the 'magic wand' of the fairy godparent (the expert) and television editing fast forward to the transformation scene, and Cinderella-like, the garden, home, person, shop….has been madeover.

- One of the key elements of this type of show is to have a disagreement or doubts about the success of the makeover project in order to heighten the tension and create some drama. The successful revelation and the change of heart at the end are usually signposted by hugs, kisses and champagne.

- Other shows in this sub-genre have been *What not to Wear* (Trinny and Susannah); *How to Look Good Naked* (Gok Wan), *The Swan/ Extreme Makeover* (Amanda Byram) and the US show *The Biggest Loser* which combines makeover with competition, where obese contestants compete to lose weight.

Genre

Surveillance Television

Various shows use the hidden camera technique from *Big Brother* to crime reconstructions. Today surveillance and the big brother mentality are a serious political issue concerning personal privacy and the amount of information held by unaccountable organisations. For television the issue is about how far a public service broadcaster like Channel 4 and the BBC can use this technique as broadcast material. Some programmes put cameras into positions where they wish to trap neighbours, bad workman or fraudsters. How far is this the role of the broadcaster? The people here, unlike with *Big Brother* are unaware that they are being filmed. These closed-circuit hidden cameras produce images which are then broadcast and often do not allow a 'right to reply' to the unsuspecting person. *Cowboy Builders* (Channel 5, 2009), *Nannies from Hell*, (1998), *Builders from Hell* (Lifestyle Channel) and others in this series have adopted surveillance techniques. They are presenting themselves as a public service telling us how to avoid disasters. However, even to be filmed these people must be known to be suspect at the very least. Audiences for these programmes are substantial. In 1997 *Neighbours from Hell* (ITV, 1997–2004) gained 11.5 million viewers (figures from Bignell, 2004). The focus was on the dramatic rather than the documentary. The effect of this type of programme is that the shift appears to be away from authorities regulating and recording of the public on CCTV showing anti-social behaviour, to the public taking control of the technology. This can certainly be seen in the use of mobile phone footage that has recently made the police the subject rather than the recorders of incidents.

Extreme Reality

Crimewatch (BBC1, 1984–)
This is one of a number of programmes about real serious crimes which are often reported on the television news and in the newspapers. This link to real extreme events is emphasised by elements such as the music and fast editing.

Crimewatch is at the edge of reality TV and moving into public information, but it still blends factual reporting with reconstructions so adding to the dramatic element and uses ordinary people like police men doing their job. Other shows focus on the emergency services, life-boat crews and so on.

Conclusion

Having looked at several strands of reality shows it is possible to identify certain generic qualities which include:

- Apparent reality and the intimacy of ordinary people's lives.

- Celebrities put in situations to reveal their ordinariness.

- A selected reality for entertainment value.

- Natural as well as contrived situations.

- Being unscripted suggesting immediacy, a sense of 'now' – although there may be a scripted voice-over or a rehearsed piece to camera.

- Being unplanned – although producers might plan to cover particular areas or put in a particular scene.

- Participants who are selected for their persona.

- Participants being encouraged to accept particular roles.

- Narrative structures using dramatic devices such as crises, roles, enigmas.

- Location shooting outside of formal studios.

- Informal cinematography.

- Low technical qualities, sound and lighting.

- Editing for effect or to provide a point of view.

- Possible interactivity.

In Chapter 4 we look in more detail at narrative structures which are closely linked to genre and at the detail of how meaning is constructed through textual elements.

NOTES:

Activity 4 – Genre

Aim: To understand that genre depends on many factors.

Objectives: To help understand:

How can we put together such a diverse group of programmes?

What are the conventions and codes that make a reality show?

- Teacher: Prepare a number of small blank squares of paper.
- In groups brainstorm as many reality shows as you can.
 Write the title of each one on a separate sheet of paper.
- Put them into groups; give each group of titles a label. Discuss these labels and agree a set of names (e.g. docu-games, docu-soaps, makeovers).
- Now list the shows in your notebook/folder under the headings you have given them. As you meet other shows add to your lists. You may need to make new sub-genre categories so leave space for these.

(N.B. This activity could also be done on large sheets of paper to be displayed, so that as reality programmes are used/discussed they can be added).

Student Activities

Activity 5 – Fact or Fiction

Aim: To consider the different purposes of a reality show.

Objectives: To see what different focuses are seen.

To understand that a variety is required.

➘ Teacher: Pre-record a reality show. (N.B. Activities 9a–c can also be used with this show.)

5a) Watch a reality TV show.

5b) Put the following in order of importance for that show:

A. Education.

B. Entertainment.

C. Information.

Extension Activities

5c) Discuss whether you think the programme has a bias? If so what is it?

5d) Do you think the programme is a 'window on the world' or do you think it is a fabricated world? Explain your answer.

Activity 6a – Participants

Aim: To consider how participants are used in a reality show.

Objectives: To use knowledge about codes and conventions.

To begin to understand representation.

To do a practical exercise and reflect on its effect.

➤ Teacher: Prepare a slide show of images of participants on reality shows using Google images or similar search engines.

Having looked at some reality shows when choosing participants from the general public, what criteria do you think the producers might use?

(Some ideas could be funny, good looking, clever, ethnic minority, gender, class, quirky.)

Activity 6b – Parallel Editing

In a docu-soap about an airline there are two parallel narratives, one of an illegal immigrant trying to enter Britain, the other of a 'stow-a-way' reptile in a box of bananas.

How could these two events be edited together to create either comedy or condemnation of participants?

• Draw/sketch/write either the comedy or the condemnation angle of the parallel edit as a storyboard.

Discuss its consequences for the representation of immigrants.

Text

Chapter 4 Text – Narrative (Macro) and Textual (Micro) Analysis

By the end of Chapter 4 you should be able to:

- Analyse the narrative structure of a reality show.

- Identify the different technical elements which combine to create meaning in a frame.

- Understand that these are choices made not only for technical reasons but also for cultural and social reasons.

- That a language of 'reality' exists.

⇒ Activities 7a - 9b

In Chapter 3 on generic conventions and codes reference was made to some of the macro elements that make up a reality show. This chapter looks more closely at the way that narrative is constructed and briefly at the micro level through technical codes and conventions.

Narrative and genre are closely linked. The way a story unfolds, the 'types of characters', the themes, will depend upon its genre. Fiske (1987: 167) referred to the building of a narrative as establishing ritualised boundaries which depend upon the genre.

Although not a dramatised narrative of a fictional story the reality show will still have a narrative structure. Often the narrative structure can be likened to melodrama with an enclosed location and emotion on display. This has suggested that Reality TV, like soaps and melodramas, is a 'feminised form' which demands emphasis on personal relationships rather than action – they have moral closure and appeal more to a female audience.

Jade Goody (right) leaves the *Big Brother* house, far right

(N.B. There are many narrative theories; more detailed explanations are given in general Media Studies books like *Exploring the Media* (Connell, 2008: 25–31) and websites like www.mediaknowall.com. The main ones referred to here are Todorov; Propp; Barthes; Lévi-Strauss.)

The role of narrative is:

- To build a story with both the back story, the present and the possible future.

- To try to position the audience to accept a point of view.

- To use plot (the order in which the events are revealed) to engage the audience.

Each narrative has a macro structure and micro elements which are helped by codes. Barthes' five narrative codes consist of two primary and three secondary codes. The primary codes look at the movement of the narrative through the use of enigma and disclosure, stopping the narrative and then moving it forward.

So for example when we see the housemates enter we will ask ourselves how are they going to behave (enigmas) and when we see one wave exuberantly whilst another looks guarded (actions) we understand their characters and the roles they may play.

The three secondary codes look at signs through the semic code, symbolic and cultural codes. So as we look at an image from *Big Brother* we are looking at signifiers such as gender, age,

NOTES:

ethnicity, dress codes, the way a person talks, all of which will help to identify their position in the narrative. We will note symbols such as a ring on a wedding finger. We will understand the title of the show because we have cultural knowledge of George Orwell's *Nineteen Eighty Four*.

At the macro level Todorov explained narrative structure as:

- The opening which establishes the initial equilibrium.

- A disruption caused by an agent of change which initiates disequilibrium.

- This is resolved by the actions of the characters.

- A new equilibrium is established. Thus:

Exposition	→	Disruption	→	Complication	→	Climax	→	Resolution

So if we apply this to a docu-game: a group of people are selected for a show (initial equilibrium), they are put into artificial surroundings (the agent of change), they have to go through trials and tribulations (disequilibrium), there is a final winner (new equilibrium). The change between the initial and final stage is often ideologically significant. For example who the winner is of a docu-game may tell us a lot about the type of society we (or at least the people who have phoned in and voted) would like.

There are interpretative frameworks which nudge a viewer into some form of expectation through trailers, voice-overs, anchor presenter, which will influence reception.

The narrator/ee positioning is as important for the types of messages which are conveyed as are other elements. This is often associated with editing.

Editing parallel stories to be juxtaposed can make implicit value judgements. The editing may be done to provoke emotion or judgement. Compare for example two young women who have just had their first baby. We may cut from one who sits and smokes, drinks and is more interested in 'texting' her friends than talking to her child, with another who follows health advice

and communicates with her baby by touch and talk and only takes it into a smoke-free room. We can see how this juxtaposition would comment upon their relative parenting skills. However this may not be the whole story as the context in which these two young women gave birth could be very different.

Another factor is the manipulation of time and space. What fly–on-the-wall, cinema-vérité and other similar styles had wanted was a verisimilitude to real life. In terms of broadcasting it is impossible to use real time except in short bursts as everything has to be scheduled (unlike the person who web-camcorded their life 24 hours a day). So another factor is how the narrative is manipulated through editing to fit 30 or 60 minutes and how we as the audience are positioned by these choices. Although a drama will manipulate time and space continuously, reality television tends to be more likely to allow real time and real spaces to be part of the process. This of course adds to its reality effect.

The participants often take on the narrative roles that Vladimir Propp identified in his study of folk and fairy stories:

- The father figure (who sends the hero off on a quest).

- The hero (with whom we are meant to identify).

- The blocker (who stops the hero in getting to their goal even if they are doing it for the best of reasons).

- The villain (who is the baddy).

- The helper (who helps the hero to gain the goal).

- The false hero (who we think at first is the real hero).

- The goal (princess, prize, e.g. fame).

Finally Lévi-Strauss used binary oppositions to show how meaning is created in the way that narratives are constructed. The obvious ones are the hero/villain roles. There can be many others such as male/female, child/adult, upper/lower class, urban/rural, real/unreal. The meaning of a narrative is usually seen at the meeting point or conflict of these opposites. For example who is the hero and villain can have ideological significance as with the Shilpa/Jade opposition in *Big Brother* in 2007.

To reiterate, the key elements of a reality show are:

- Intimacy – often conveyed through tight framing.

The housemates of *Big Brother* with attendant signifiers, far left

Text

- Immediacy – signified through shaky hand-held cameras.

- Interactive – with on-line and red buttons, etc.

How Are These Achieved Technically?

'…hand-held camera, the cramped shot, and "natural" lighting, often supported by unclear or inaudible (and therefore "natural") sound…the impression that the camera has happened upon a piece of unpremeditated reality which it shows to us objectively and truthfully…' (Fiske, 1987)

New technologies such as light-weight cameras, digital editing, surveillance cameras, web-streaming have all contributed to the immediacy, unplanned, intimate structure and made them relatively cheap and therefore popular with producers. These technical developments have also contributed to their interactivity which is an important pleasure for audiences.

But when you look at the television how is meaning created? Camera work, editing, lighting and colour, sound (both diegetic and non-diegetic), *mise-en-scène* (which include composition, positioning of objects) and performance all contribute to meaning. A good way to begin an analysis is to write these elements down, list all those which appear in the frame (denotation) and then suggest what these connote and what meaning is represented by these in combination (what Barthes referred to as the myth).

There are several sources for detailed guidance on technical analysis including media text books and websites (see references). Here are a few points to help with analysis of reality shows:

Camera – How does the camera frame its shot? Is it in close-up or as a long shot, or one of the stages in-between? Is it carefully framed or un-posed? Is it tight or loosely framed? Are the angles high or low and what does this convey? Politicians, etc. are often in mid/long shot whilst real people are in close-ups particularly if in state of emotion, so ask what effects do camera choices have on the meanings we read into the images.

Editing – All programmes are edited in some way even if it is the choice of camera in *Big Brother*. When editing is more obvious, look for the length of takes and the style, whether it is montage or continuity editing. Also look out for cuts to create a point by juxtaposition of particular images and what meanings this suggests. See if there is parallel editing of two stories which might be significant.

Sound – This includes both sounds which occur within the frame (diegetic) and sounds outside the frame such as background music or a voice-over (non-diegetic). Sounds of voices, style of voice, accent, tone, gender as well as sound effects all contribute to the atmosphere and meanings created. The narrator's voice-over may help to direct the narrative thrust of the programme or to anchor the images into a particular meaning. The style of music and instruments may be significant.

Mise-en-scène – Has the *mise-en-scène* been constructed or is it a natural or real setting? Reality TV will sometimes be filmed in constructed sites such as with *Big Brother*. It is then important to look at the way the set has been designed and what meanings this suggests. Other reality shows will use real locations, however even these may have been 'organised'.

Lighting and Colour – Consider the type of lighting used and colours used, so maybe a red tone might connote a harsh, angry environment or in a different context might have a more romantic or even sexual connotation. Natural lighting, perhaps at night in a hospital ward, might convey a feeling of immediacy and reality.

NOTES:

Presenters – What impression do you get of presenters? Are they ordinary people as in a video diary; a celebrity as with *Big Brother*; or an authority on the topic such as in hospital? One way of understanding what the presenter represents is to look at their non-verbal communication, such as codes of dress and the way they behave. Another area to look at is the linguistic style used and whether for example they use Standard English and Received Pronunciation or other dialects and accents. Gender choice may also be significant. Is it a male voice-over on a crime show or female? Consider whether direct or indirect address is used, or if it is formal or informal.

Participants – How are interviews presented? Is the interviewer in the frame? Are there experts providing an analytical framework for understanding participants? Is it vox-pop? Do we believe one group or individual more than another? Why? Look at the technical codes such as editing and camera angle used to present them to us. Also, as with presenters, see how they are dressed, how they speak, how they behave.

The combination of codes, conventions, techniques and structure creates meanings for audiences who in turn will add their own gloss from their own perspectives. Chapter 5 looks at the nature of audiences for Reality TV.

Student Activities

Activity 7a – Looking at a Title Sequence

Aim: To deconstruct a text.

Objectives: To practise deconstruction in order to be able to construct own title sequence
To reason why elements have been chosen.

�’ Teacher: Prepare several title sequences from different types of reality shows.

Watch a title sequence several times and then list how it is constructed. Use the following elements as your basis for analysis: camera angles, camera framing, lighting and colour, sounds, graphics, special effects, editing styles, objects, people and locations.

Name of Show		
Element	Connotes	Meaning
e.g. lighting	natural, sun light	suggests not artificial etc.

- Repeat with a different type of show.
- Compare how different sub-genres are signified.

Activity 7b – Logos

↘ Teacher: Prepare a series of logos for analysis from websites.

Analyse logos from a range of shows using technical codes.

Discuss how the different logos identify different sub-genres.

Student Activities

Activity 8 – What's in a name?

Aim: To understand that words are signifiers.

Objectives: To show how titles convey meanings by different methods such as direct signifier, connotations, cultural knowledge.

Here are some titles of reality shows:

- What do the words in the title connote (suggest) will be the focus and the sub-genre of each of these shows? (N.B.: If completed Activity 4 use these categories.)

Title	Focus	Sub-genre
Driving School		
Survivor		
Pop Idol		
X Factor		
American Idol		
Dancing with the Stars		
Changing Rooms		
America's Next Top Model		
Cheaters		
Wife Swap		
Traffic Cops		
Bands on the Run		
Border Security		
Celebrity Duets		
The Batchelor		
Hell's Kitchen		
Charm School		
The Biggest Loser		
Life Laundry		
Ghost Hunters		
Hell Date		

Activity 9a – Narrative Roles (Propp)

Aim: To introduce students to the idea of different roles inside a narrative.

Objectives: Analysis of a sequence for narrative roles.

Identifying how these can change.

Suggesting types that might be identified.

- Teacher: Record a reality show (you could use the same one as for Activity 5a).
- Watch a reality television show such as a docu-soap or docu-game and see if you can give the participants a Propp role.

Name of Show	
Role	Name of person* who takes this role
Hero	
Villain	
Donor/wise person	
Helper	
Dispatcher	
False hero	
Goal	

*Remember a person may play more than one role at different times.

Student Activities

Aim: To understand the macro narrative structures.

Objectives: Analysis of a whole text.

Use of specific theories:

- Analyse the structure of the show using Todorov's initial equilibrium, agent of change, disequilibrium, new equilibrium to show how a narrative structure is important.

- Discuss whether there are any binary-oppositions (Lévi-Strauss) evident.

Segment one programme into:

Introduction and title sequences.

Part 1 – Presenting the problem.

Part 2 – Presenting a possible solution.

Part 3 – Working towards a solution.

Part 4 – The solution.

End credits and any hooks to next show.

- Could this breakdown apply to other shows?

Extension Activity: Using your results from these narrative analyses, what do you think are the meanings about society which are conveyed by this Reality TV show?

Audiences

Chapter 5 Audiences – 'Peer voyeuristically …' (Kilborn and Izod, 1997)

Having completed this chapter you should understand:

- That different audiences watch different types of reality show at different times.

- That audiences have different needs and the pleasures they get from watching this type of show are complex.

- That audiences are also producers of meanings and can influence directions.

- That audience theory has two basic approaches, that of active or passive audiences.

⇒ Activities 10-15

General Introduction

Is the technological interactive and savvy teenager in control of the media or are they being manipulated into more consumerism and less intellectual questioning? Has the ability of the media to be mobile (out on the street) and for audiences to also be mobile (videophones) changed fundamentally our relationship with the media? These are fundamental and over-arching questions about the media and audiences and the debates they generate are central to understanding the reality genre and its appeal.

For some theorists audiences appear to be self-selecting autonomous individuals who choose to watch – or not – a TV programme and to read it in different ways (active). For others audiences are not in control but are targeted, created and produced by media institutions (passive). But from which ever angle you approach it without an audience there would be no media to study.

Audiences are constructed through technical languages, genres and narratives; they are targeted by schedules and marketing; and controlled by specific technologies which reflect a social context; and all within an historical setting.

Audiences are complex, shifting, ephemeral groups and for the producers they can be fickle in their uptake. To be able to judge your audience and their wishes and desires is an important part of the television industry.

There are basic questions that arise in regard to audiences:

- Are audiences being manipulated by the industry or are they constructing meanings?

- Are audiences influenced by what they read and change their beliefs and behaviour?

- What pleasures do the audience get and why do they consume certain texts?

- How does the fast changing media-scape and technology change the audience and their experience?

Factual Audiences – the Institutional Approach

For broadcasters the measurement of audiences is essential to gauge the success of a programme. BARB (www.barb.co.uk) is one of the organisations which give them information on numbers and reach. Most broadcasters also have their own audience surveys and reviews.

Deregulation since the 1990 Broadcasting Act, combined with new technologies and inevitable commercial pressures, have changed how audiences are structured. The mass audiences of radio and television in the middle of the twentieth century where nearly half the population would sit down to watch an episode of *Coronation Street* or a significant national event are no longer seen except in exceptional circumstances.

Family watching television 1958 (audiencetheory.files.wordpress.com/2009/04/fa...)

The new technology of video and time shifting during the 1980s began the 'rot' in the decline of large audiences. Convergence and digitisation means that audiences can no longer be seen as a mass but are far more diffused, fragmented or 'extended' (Couldry, 2000). So audiences are identified as being niche groups and are targeted as such by the industry.

This has influenced the content mix of television. Whereas factual programmes were seen as part of the general mix of programming in terrestrial television, today there are many specific genre channels. Weighty documentaries although providing a public service, do not attract large audiences and the reality show has taken up much of the factual time on terrestrial television. They provide a nod to PSB being factual but because of their lighter treatment provide entertainment for the audiences and their popularity (shown by audience ratings) means that these more accessible factual shows or 'documentaries which peer voyeuristically into people's lives or which are politically uncontroversial are being given preferment' (Kilborn and Izod, 1997: 239).

Audiences

A family gathers around the TV set, circa 1958, right

Audience Studies – Reception Theories

There have traditionally been two ways of understanding audience reception:

- One sees them as passive receivers of messages, the effects approach.

- The other as active participants, the uses and gratification approach.

The first approach often termed the media effects position is associated with the view that although audiences may believe they are not influenced they are in fact receiving messages all the time which influence their values, their knowledge of the world and their beliefs about society. The effects debate has been linked most strongly with the hypodermic and the two-step model which suggests that we are unconsciously influenced by the media to copy what we see (copy-cat theory). An extension of this approach is called the Cultivation theory (propounded by George Gerbner amongst others) which stated that there was a relationship between heavy media use and undesirable behaviour, such as violence. The audience is in effect 'blind' to this process. It happens behind their backs, an unseen process. Researchers have used various techniques to try to establish how far people and particularly vulnerable groups such as children and young people have been influenced by the media. The reporting of the (March, 2009) shooting of school students in Germany is an example of the 'hypodermic' model. That is a person watches a particular event and takes the message without resistance, like the liquid from a hypodermic needle. In the German killings one of the causes implied in the media were the number of violent video games the killer possessed. The cultivation theory suggests that we are unlikely to go and chop people up having just seen a horror movie, but we may be more subtly influenced and behave more violently having watched many violent acts. For example, if we mostly see young women as victims in a horror film does this influence the way we think about them? Do young women feel more vulnerable as a result of being seen as victims on numerous occasions?

Regulation and censorship are often based upon this theory and the 9 pm watershed on terrestrial television is partly the result of this belief.

In contrast the active audience model sees people using the media to gratify needs, the Uses and Gratification model. Audiences select and use material creatively. They are therefore more powerful if in more subtle ways than is admitted by the media effects position. The media have to find out what the needs are of the audience and try to fulfil them whereas in the passive model the media creates the need which they then fulfil in the most profitable way for their owners.

Researching Audiences

Research into audiences has been done through both qualitative and quantitative studies. Particular interest in the qualitative approach has been shown by ethnographic researchers who observe how programmes can influence a small group or individual. The audience is seen as many 'audiences' each working within their own framework to decode and read texts.

The evidence that audiences use the same material for different purposes and read the texts in preferred, negotiated, oppositional ways has been well documented. For Reality TV there is the additional aspect of its link to the real world and how far the viewing of reality shows may influence the way that readers link to other texts, such as dramas set in hospitals, and their own reality. How far does this intertextuality influence

NOTES:

the reading of the reality show?

The question of who is in control of the messages being given suggests that there is a power relationship. Some would see the potential for democratisation as a positive effect with access for previously disempowered groups now a possibility.

Additionally the media today are not just local institutions being viewed by parochially small groups they are global institutions. The way that television programmes can be adapted for global audiences is important in that it suggests not just an economic power but also a cultural 'invasion'. Cultural imperialism is often quoted as one of the dangers for audiences who may accept and import values which are not part of their own world.

The technologies that have made Reality TV possible have also raised the question of who is in control of these technologies. How far have censorship and regulation, both imposed and self, given the audience a biased view of the world?

The following example taken from the web shows how the audience and participants are constructed by the industry.

Baby Beauty Pageant – New BBC Documentary Needs You

BBC DOCUMENTARY Contestants sought for Children's Beauty Pageant.

Do you dream of being in a beauty pageant?

Are you aged between 6–13?

Would you like to show off your beauty and talent on the catwalk?

The UK's first ever pre-teen beauty pageant is taking place in March/April and we are looking for the future Mini Miss and Little Man. The pageant is being independently organised and will be filmed as part of a BBC documentary. Contact us ASAP for more details on how to apply.

Category:

Reality/Documentary

Applications Close: 15/04/2009

Filming in: The South

Applicants from: All of the UK & Eire

(From wwwbeonsceen.com accessed 26/03/09)

What comments could be made about this show in terms of audience?

If you go to the Internet and search on 'reality TV auditions in the UK' you will come up with a selection of sites offering auditions in all sorts of reality (and other) shows. Who are the intended participants in these shows? How far does the audience believe that it too could have been on the show if they had bothered to apply? In America there is even a special school for 'wannabe' reality TV stars where they are given advice on how to audition and keep calm in difficult situations (www.bbc.co.uk/ CBBC Newsround, 25/08/2008, accessed 27/02/2009). What the programme-makers want is for the audience to be part of the show, to be a performer if only vicariously.

In particular youth audiences have been targeted by the combination of elements of brand and spin-off goods. The teenage audience is a very valuable market but a difficult one as they tend to watch relatively little television but have a large disposable income. *Big Brother* was designed to appeal to this audience within global television but with each show targeting local cultural differences. Its success is based upon the fact that it knows its audience.

Although the biggest audiences are almost without exception the soaps, *Big Brother* which targets the youth audience wins hands-down on the late evening time slot in which it appears. The numbers build up during the week and peak at the weekend when eviction occurs. *Big Brother* is particularly successful at targeting the difficult young male audience. It also has a relatively affluent and educated audience with 51 percent of students claiming to be regular viewers (Sparks, 2007, quoting Jones in *New Media and Society* vol. 5, no. 3, p.6). However those reality shows targeted at a more general audience such as the late afternoon and early evening shows have an older, broader, more mass appeal.

Today audiences are being targeted through convergence of media forms, but does this change the audiences' interaction? Media observers suggest that audiences have changed from being audiences of a one to one, or simple form through to mass audiences with the development of the mass media in the twentieth century, but that they are now increasingly diffused. What this means is that we no longer all sit in front of the television in the evening to watch the same programmes, but are consuming texts through such forms as computers and phones as well as the traditional screens. Additionally we are time shifting our watching such as through i-players, podcasts and downloading. We can be at work and keep up with the news about reality celebrity stars, as with the tragic death of Jade Goody, through news organisations' on-line services. We can receive updates on the latest *Big Brother* situation on our mobile phones – anywhere.

Audiences

The fragmentation of the audience has certainly hit the industry with the migration of advertising from terrestrial television to other forms such as viral advertising on-line. But has it also influenced us as individuals, the audiences? Has this new experience of consuming changed our relationship with the media? Does sitting alone in your bedroom change your relationship with the global market place? Does the chance to vote or interact in other ways alter your personal engagement?

Are you an Audience or a Producer?

Trying to research audiences who extend over such diverse contacts with the media through physical displacement and with involvement through social and political differences is certainly a challenge. Included in this displacement is of course the blurring of barriers between who is the producer and who is the receiver of the text. New technology has increasingly allowed this boundary to become less defined. Many people are posting their own videos on-line and contributing to forums, producing blogs and are twittering, all for consumption of an audience. The line between performer and audience is perhaps therefore not a horizontal split but a vertical continuum.

However this idea of interaction does not address the fundamental question of some media observers and that is the power beneath the continuum. The political-economic view suggests that this is still in the hands of a few and that they are still the producers of the discourses (Michel Foucault, 1980) which provide the basis for our beliefs (ideologies). The producers have for example the power to select certain contestants for shows like *Big Brother* (Channel 4, 2000–10), *Pop Idol* (ITV1, 2001–3) and *Britain's Got Talent* (2005–). The producers also select which types of information are to be broadcast. So our perception of being part of the process may be illusory.

Reality TV Audiences

One way of looking at audiences is to see how they are addressed, and the different modalities used. Audiences expect truthfulness (verisimilitude) in factual programmes. The claim of the reality show is that it presents a 'reality' of the world around us, the social world which at least some of the audience can recognise whilst others are keen outside observers. There is of course a continuum on how near to the reality of most people's lives some of the reality shows reach. A police show of serious crime footage will fortunately only touch a small minority who have been victims of crime. But the majority of the shows which come under this umbrella are about everyday life such as workplaces and home-life with which most people can identify. If not directly similar there are enough points of contact to make it seem as though we are observing someone's life just as they could observe ours. This is the fundamental change in the relationship between the media and the audience. It is now possible to imagine ourselves, the audience, on-screen. Rather than a one-way process of the few 'elite' like actors, presenters and producers showing us a particular, and often irrelevant to everyday life, view of the world, we can now see ourselves, or at least someone like us: a mum, a dad, a teenager, a boss, a worker on the screen in more than just quiz or game shows.

Researching the audience for Reality TV has posed certain questions. The narrative constructed is not just a hypothetical one but one being lived out. Thus the meaning is circulated in a far more direct way between text and audience. How does Reality TV influence the audience extended beyond the immediate broadcast? Given the relative newness of the genre, research on audiences for this type of show is not extensive. The view often taken is that Reality TV fuels the voyeuristic nature of the audience.

Dr Glenn Wilson, from the Institute of Psychiatry, stated:

NOTES:

'…we are basically nosy…We are also naturally envious, fearing that others might be having a better time than ourselves. …inwardly delighted to discover that those who appear to be enjoying a privileged lifestyle amid luxurious surroundings are just as miserable as the rest of us. …The characters in these series are usually larger than life. They feature eccentric individuals happy to exhibit themselves…' (Wilson, 1998)

These shows are seen as comparable with the gossip columns or agony aunt pages of newspapers and magazines.

Qualitative research on audiences shows that in fact audiences are using a programme like *Big Brother* as part of their community building as they did with other popular genres such as sitcoms and soaps in earlier decades. They are cultural points of reference against which judgements are made and discussed. Another factor is that they are judging the events shown against their own lives. How authentic are the scenes? Would people behave like that?

As Hill states:

'The focus on the degree of actuality, on real people's improvised performances in the programme, leads to a particular viewing practice: audiences look for the moment of authenticity when real people are "really" themselves in an unreal environment.' (Hill, 2002: 324 quoted in Gillespie, 2006)

In other words they are viewing with an openly sceptical mind and judging how far the participants are behaving normally or are in fact acting up for the camera. Hill's research showed that interviewees were judging their behaviour against that shown on-screen. The ambivalence is seen in these extracts from interviews about a Reality TV show following young men on holiday in Ibiza:

'you see exactly the same thing…if the camera's there, everyone is going to act up…they'd be worse if the cameras weren't there…it could have got naughtier…all of us guys have been Jack the lad' (Hill, 2004: 74–7).

The sense of judging how far the scenes shown were close to their own experiences and how far they were constructed for the cameras is clear. The early reality shows tended to celebrate ordinary people's lives and work. They were often work based which is seen as a central part of human activity, such as in a hospital or a zoo, however the game show format focuses on leisure and consumption. It jumps from the public world of work to the private world of relationships. For audiences it provides a window

on the personal with a chance to judge behaviour without personal consequences:

'Reality gameshows have capitalised on this tension between appearance and reality by ensuring that viewers have to judge for themselves which of the contestants are being genuine. In fact audiences enjoy debating the appearance and reality of ordinary people in reality gameshows. The potential for gossip, opinion, and conjecture is far greater …because this hybrid format openly asks viewers to decide not just who wins or loses, but who is true or false in the documentary/game environment.' (Hill, 2005: 70)

This has been central to some of the criticisms of this genre and of a celebrity culture which focuses on the people who are celebrities for being famous rather than because of talent or through their work. Celebrity appears to be an attractive alternative to the world of work for many people who may have rather mundane occupations. It provides an opportunity to be recognised beyond the anonymity of their everyday roles. But as the title of Couldry's 2004 article suggests it teaches us 'to fake it' and has created ritualised norms of behaviour *on* reality shows, and maybe also *in* reality.

However audiences do not just watch and judge a reality show, they also interact in other ways. They may actively vote, read articles, listen to media discussions, talk with friends, send text messages, and participate in blogs and so on. All of this is made possible by new technology and convergence.

A big on-going production like *Big Brother* is an event which for audiences requires, or at least this is what the producers would like to suggest, attention throughout the day and night not just for the 60 minutes or so of the show's main terrestrial 'on air' time. The hype created by the media itself may encourage more 'footfall' to the show's touch points and therefore more interactivity. Does this type of audience participation change the nature of audiences?

Questions that this discussion has raised:

1. If we are fragmented audiences with new ways of consuming media are reality shows one way of staying connected? Is this why they are popular with audiences? Or are there other more important factors?

2. What do audiences use Reality TV for? Do they judge their own behaviour, beliefs, values against those on the reality shows and are then influenced to change their behaviour? Or are they uninfluenced?

Audiences

3. Are the media exerting power through institutions and symbolic power over the way we think? Or are we able to reject or negotiate meanings?

Discussion: One view (as passive receivers) of audiences would state that the programmes are produced to make a profit and/or to raise audience ratings. They deliver beliefs (ideological discourses) whilst they are entertaining. They limit choices maybe giving 'less for more' in terms of channels and choices of programmes in the schedules for example. Media power works through the audience to shape perceptions.

Others would see audiences reading texts in many ways (active) which are therefore polysemic, having many meanings, and being open to different interpretations; preferred, negotiated and oppositional readings (Hall, 1980, summarised in Fiske, 1987). There is no direct one way line of communication. The meanings within a text are open to negotiation by active audiences who use the media for different purposes. Factors such as class, gender, age and ethnicity will all shape the audiences' relationship with a reality show. Thus the audience will challenge dominant readings and are empowered by being both the subject of the shows as well as 'producers' through interaction.

The fans that are created for each programme who become avid watchers and participate actively in all the access points made available are there for the short term but are vital for producers. They will become a temporary community or 'tribe'.

Conclusion

Media audiences have been the focus of much research, particularly with the onset of mass audiences and the ability of the lower classes, the 'great unwashed', to consume texts. Newspapers in the eighteenth century were regulated with a stamp duty to try to stop the publication of

material which challenged the status quo. Later new media such as films and of course broadcasting became a target for censorship and regulation. In relation to reality shows the effects of the lowering of standards, the celebrity culture and the breakdown between the private and public are all concerns. The main thesis on which all this attention has been based is that the media can influence people, especially the vulnerable and uneducated. This was originally based upon a passive view of the audience which had its roots in the Marxist idea of society. More recent research has taken the view that audiences are active in their reading of texts and more media literate than the passive view suggests. However, the power of the media to influence even if only on a superficial level and to change behaviour such as through advertising, is certainly one on which the industry base considerable expenditure. Chapter 6 looks at the ownership and professional practices within the television industry.

NOTES:

Activity 10 – Who is the Audience?

Aim: To understand that there are many types of audience.

Objectives: To research other audiences.

To understand there are different ways of researching audiences.

➘ Teacher: Either set this up as a whole class activity with you doing the on-line searches, or as an individual student activity in class or at home.

Activity 10a – Write a description of the 16–19 television audience. Include in it what they like/dislike, their interests, how they spend time, when they view television and the types of show they enjoy.

Activity 10b – The BBC's View

- Look at the BBC website to find out how they describe their audiences: www.bbc.co.uk.
- Once you have logged on go to the commissioning part of the site.
- Go to BBC.co.uk commissioning.
- Go to BBC Vision.
- Go to day time entertainment.
- BBC Vista BBC1.
- At bottom *our audience 16–24*.
- Read this description.

Do you agree with what the BBC say about this audience? Discuss with your peers and with some adults. Compare your descriptions in 10a with the BBC's. What advice would you give to the BBC?

Student Activities

Activity 11 Audience Research

Aim: To understand how audiences are researched.

Objectives: To do some primary research on audiences.

Activity 11a – If you have not done Activity 4, brainstorm the titles of television programmes that you regard as reality shows.

Activity 11b – Within the group rank them in popularity. Look at the most and least popular – why do you think they have these positions? Discuss and note down points made in this discussion. Keep these points so that you can refer to them when developing your own ideas.

Activity 11c – If you did the same research at an old persons' luncheon club, do you think the order would be different? In what ways? Why?

Begin like this 'OAPs are people over 60 years. The differences would be……..because……….'

Extension Activity: If you have access to a community group here is some primary research you could do to find out the different audiences. Draw up a questionnaire to find out the popularity of different reality shows with different demographics (audiences).

Activity 12 – Audience Pleasures

Aim: To understand some of the psychological needs of audiences.

Objectives: To do primary research on needs and gratifications of watching reality shows.

Why do you watch a Reality TV show?

Write down the name of the show you most enjoy

Name of Show………………………………………………..

✓or x what applies to you (lay out as chart with boxes for ✓/x)

Is it because you like watching ordinary people and their lives?

I like the sense that this is real life?

I like watching behind the scenes of other people's lives?

I enjoy seeing people succeed/make a mess of something?

I identify with particular people on a specific reality show?

I like watching as a voyeur (watching knowing you are in a more powerful position than the people on screen) such as with *Big Brother*?

I enjoy seeing things happen and wondering how I would behave (second-hand, vicarious)?

I enjoy the stories of other people's lives?

I think that some serious issues can be raised through entertainment?

Any other reasons you can think about – add them here.

Student Activities

Activity 13a – Audience Pleasures continued. Looking in more detail at some of the pleasures

Read each pleasure listed below and write a short paragraph for each of the three pleasures using your response to the questions.

Pleasure 1 – Watching ordinary people.

- Why do you think people like watching 'ordinary people'?
- Is it because ordinary people can be unpredictable?
- Is it because we can identify with them?
- Do we empathise when people talk about everyday things?
- Can you think of other reasons?

Pleasure 2 – Being shocked.

When we watch a reality show and something 'shocking' happens, such as people being ill, fighting, or behaving irresponsibly, why do we keep watching?

What are the 'pleasures' of this type of viewing?

Pleasure 3 – Public confessionals.

Why do we watch people telling their intimate thoughts to the camera (and the world) such as feelings about being fat (*Fix My Fat Head*, BBC1, 5 May 2009), or in the *Big Brother* confession room? Is it because we like to know how others like us feel, or are we just nosey? Are we entertained by private revelations or embarrassed?

- Read the following comments from *The Andover Advertiser* 'Have Your Say' article 26/08/09.
- In response to the question: 'Does reality TV really turn us on?' the paper reported the responses of interviewees in the town centre. They were universally negative and included:

'I'm sure people will get bored of it…'

'It reflects a lack of creativity …

'…mind numbingly dull…'

'…it just goes on and on…'

'…they have sensational headlines making the regular people into famous icons…'

'…seem to crave fame by doing anything rather than by doing something meaningful…'

'…people …trying to do anything to get themselves noticed.'

- Does your research agree with these responses?

Activity 13b – Audience interactivity

- How many ways, apart from watching, can audiences take part in a show? List them
 (e.g. Celebrity magazines, visit programme site, email contestants, read the website, join on-line chat groups, SMS messages, voting).

- Research – How many of your group have interacted in any way with a reality show? What is the percentage – is it high or low?

- As an audience what pleasure do you get from participation, such as by phone-ins, voting, or going onto an on-line forum, or choosing options through the red button or any other interactive mode? List the pleasures of interactivity.

- Why do people NOT interact with these shows? (Do some qualitative research by questioning people who do not interact.)

Student Activities

Activity 15 – Participation

Aim: To observe different participants.

Objectives: To understand motives for taking part in reality shows.

↘ Teacher: See preparation for activities 6a and 19a.

Why do people volunteer to be on shows, or to show their home movies, where they may be humiliated?

Would you confess on television?

Would you want to be part of a docu-soap, docu-game, makeover or other type of reality show format?

Give your reasons:

- Is it for fun?
- Is it for personal discovery?
- Is it for fame?
- What do you think would be the positives of being picked?
- What would be the negatives?
- How much power do you think participants have over the final broadcast programme? (Participants usually sign a contract of 'informed consent'.)

Chapter 6 Industries and Institutions – '[C]ompelling real-world questions and ... high entertainment values' (www.bbc.co.uk/commissioning)

Having completed this work you should understand that:

- Producers are there to make money.

- The media market for audiences is competitive and packed.

- Scheduling helps to target audiences.

- Institutional constraints such as budgets and time influence the type of programming we see.

- Television channels have a profile persona.

- Audiences are also producers in that they select options and contribute.

- Regulation can influence content.

⇒Activities 16-18

In 2003 Brian Winston, then Professor of Media and Communications at the University of Lincoln, in response to a discussion on reality television stated that the 'tendency to read fads as deep-seated meaningful historical trends is the basis of so much stupidity' and went on to say: 'In 1997, people thought the networks would be dominated by docusoaps by 2003. Do you think the networks are going to be dominated by reality television by 2006?' (in Keighron, 2003). At the time of writing – 2010 – what response would you give to Brian Winston?

Commissioning 'The Real'

Broadcasting has always been a medium which has exploited live events, such as sporting, cultural or political occasions. These events most of which are known about in advance allowed large equipment such as cameras, etc. to be in position. Perhaps one of the most famous early televised occasions was the Coronation of Elizabeth II in 1953. This public service was seen as helping to provide the social glue and the forum space for a national identity. The ability to be 'live' is still used in these types of broadcast. But a new era has been made possible by technology which has influenced factual television with the live broadcasting of siege events, or following traffic accident victims, or recording the terrorist attacks on the Twin Towers. At the mundane level the new technology has allowed the 'live' observation of ordinary lives and it is here where broadcasters have focused in recent commissioning.

Here is an extract from the BBC

Commissioning site which shows how the BBC views the audience for reality shows:

'The Audience for Features and formats [such as reality shows] are naturally excellent at bringing younger channels to the BBC, and play an important role in doing so across BBC ONE, TWO and THREE. Always entertaining and accessible, formats on ONE should change everyday lives for the better, giving people empowering ways to view life. Formats on TWO should break new ground to appeal to 25–44 yr olds, whether it's bringing different perspectives to established subjects – or finding authentic but entertaining ways to explore otherwise complex areas. Features and formats on THREE continue to blaze a trail of originality and bravery for an audience of 16–34 year olds hungry for new ideas, without ever losing sight of the their cheeky, provocative view of the world. They are often driven by compelling real-world questions and always, always deliver high entertainment values.' (www.bbc.uk/commissioning, accessed 23/05/09)

Although public service broadcasting was seen to be integral to both the BBC and commercial channels and were part of their remit, the newer satellite and cable companies are not interested in producing expensive, small audience figure programmes unless there is a commercial advantage. Small independent companies are also unable to put the research and resources into factual programming and there have been some infamous results such as faked events for documentaries and false claims made by guests on chat shows. The making of a show with real people and real locations, no rehearsals, a small crew, no stars, insignificant capital costs makes the format attractive to a commercial television market which is currently (2009–10) in economic crisis.

The proliferation of small independent production companies began with Channel 4 in 1982 which was set up to only commission not make programmes. The numbers of independent companies were boosted in 1990 when the Broadcasting Act made the BBC use 25 percent of external production.

Channel 4's remit was to be innovative and to target minority audiences and it was initially

supported by ITV's advertising arm. This support was eventually withdrawn and by the end of the1990s it had to sell its own advertising space and needed therefore to target audiences attractive to advertisers. Its response was to look for popular new styles of programming. *Big Brother* was to be one of those and has been a phenomenal success.

So the de-regulated and market driven new media world has led to much more emphasis on audience numbers and amongst the shows which make the big numbers are Reality TV events. The final of 2009 *Britain's Got Talent* recorded the highest audience since England played football in Europe in 2004. It peaked at 19.2 million and brought in £30 million of much needed advertising revenue for ITV.

Not all are so successful. For example the American television series *Survivor!* (CBS) was bought by ITV in 2001 in response to Channel 4's *Big Brother*. The 16 contestants marooned in the South China Seas were playing for a prize of a £1 million. ITV marketed its arrival with publicity through tabloid news coverage and news stories which were generated by ITV. Newspapers and magazines ran articles about the 'event' up to four weeks before it happened. The organisation of the text messaging and other interactive elements was co-ordinated by Carlton, an ITV company. Billboards, trailers both on television and on the web advertised the show. However this over exposure was seen to backfire when the viewing figures were less than expected. The viewers were perhaps feeling that they were being overly manipulated and that their choice of winner was being decided for them so that the apparent democracy of voting was undermined.

Interestingly *Survivor* in America has been more successful than the US *Big Brother*. Why should this be so? Is it because American viewers have that sense of the Big Frontier, that ability of their forefathers to survive in the most rigorous of environments? Are they re-living this vicariously? This is speculation but it is interesting to consider the reasons for the relative popularity of different reality programmes in different cultures.

Many reality shows on terrestrial television are scheduled either for day time or early evening entertainment prime time where their relative cheapness makes them financially attractive. One exception to this cheap formula is *Big Brother*, where the estimated cost is £20 million p.a. (figure quoted by Torin Douglas, BBC Media correspondent, www.newsvote,bbc.co.uk/ '*Big Brother* to Bow Out Next Year', 26/08/09, accessed 27.08.09). *Big Brother* requires a significant layout in terms of setting up the location and the technology for broadcasting. It also has a 'star' presenter. Money is made by phone votes, branded products and merchandise such as T-shirts, games, books and DVDs. There are also text updates as well as traditional forms of advertising and sponsorship. Endemol the licence holder for *Big Brother* is quoted as making nearly 30 percent of the revenue from merchandising and licensing of branded products (Bignell, 2005). The celebrity format of *Big Brother* and other reality shows such as I'm a *Celebrity…Get Me Out of here* (ITV, first series 2002) are on a much bigger scale. For example on *I'm a Celebrity…* around 400 people support the show, including 24-hour editing and celebrity presenters who add links or cover up glitches. There are safety and security precautions for the contestants, designers for the 'trials' are employed and all this with the celebrity fees which escalate the costs.

However a successful format can be a life-line to companies struggling in harsh economic climates. The company who owned *Pop Idol*, Fremantle, predicted in 2003 that by 2006 up to half of the company's total revenue would be from income based on licences for the format and merchandising (Bignell, 2005: 23). The core audience of 16–34-year-olds made up 72 percent of the 14 million viewers of the final show of the first series (ibid.). The sponsor, Nestlé had its logo in the opening and closing of the show, but also had animated chocolate figures in the advertising breaks for which viewers could vote. So the link between the adverts and the

NOTES:

programme was explicit as part of its branding. Nestlé also made extra revenue from the voting telephone calls for the animated characters.

Advertisers are notoriously jumpy about advertising around politically controversial shows such as documentaries or current affairs and with declining revenue this has become more important. The programme format that has worked for all the channels is Reality TV. They are cheap to make, have large audiences both male and female and attract a wide demographic. In the US reality shows have taken over from sitcoms as the prime time anchor show. For example the final of *American Idol* attracted 23 million viewers, the highest non-sport audience for the Fox network for ten years (Bignell, 2005: 45):

> 'Entire channels are devoted to broadcasting them [reality television shows] and they have largely replaced the studio chatshow as the cheapest means for US broadcasters to garner mass audiences.' (Adams, 2009)

ITV has been struggling with declining revenue over a number of years as has Channel 4. The position of ITV with its 'cosy duopoly' with the BBC began to be broken by the Broadcasting Act of 1990 which led to de-regulation and an auction of ITV licences. The present drop in commercial television's revenue has lent appeal to the cheaper formats. Whilst the government has responded by lightening regulation, such as on sponsorship, and it has recently been considering product placement, a potentially lucrative revenue stream (an extra £100 million for broadcasters according to the Department for Culture, Media and Sport, see S. Dixon, *The Sunday Times*, 13 September 2009). One of the results of this shortage of funding is that the programme-makers are always looking for new and cheaper formats to attract audiences and therefore advertisers. The conundrum is always how to find those audiences…

Scheduling

Historically factual television programmes, like documentaries, which provide the educational and informational element of the public service of broadcasting, have been scheduled for lower audience number time slots. But the de-regulated market has meant that this formula has had to adapt and the new 'kid-on-the-block' factual reality TV has taken a front seat in prime time television.

Traditionally television schedulers have used techniques such as hammocking, inheritance, common-junction points (see Branston and Stafford, 1996, for more detail), to encourage

viewers to stay with one channel. But the success of the 'tentpole' shows in the 1990s such as sitcoms like *Friends* has declined and today choices of a multitude of channels and the re-playing of programmes through the Internet have meant that scheduling is a much less secure procedure. As new channels began to take hold of the market in the 1990s the traditional segmenting and scheduling were eroded. There have been significant changes in scheduling techniques such as the introduction of stripping and clustering similar programmes together.

The reality show has developed its own scheduling format. For example it tends to be a series of a limited number of episodes. If it is a docu-game it will build to a climax which might be scheduled in peak time, such as *Britain's Got Talent* whilst other episodes are outside the peak. The final of *Britain's Got Talent* in 2009 attracted ITV's biggest audience since February 2003 when an episode of *Coronation Street* got to 17.6 million. From 9.30 pm to 10 pm it had 68 percent of the television audience. The peak was reached at 9.50 pm when for the last 5 minutes of the show 19.2 million people were watching (figures from Busfield, *The Guardian*, 1 June 2009). Some formats are scheduled together such as auction shows, whilst others like *Big Brother* are broadcast several times during the day.

Advertising or trailing programmes is used to attract audiences. Advertising appears in newspapers, magazines, on buses and hoardings particularly for a high profile show like *Big Brother*. Shows will use controversy to maintain audiences. Maybe the earliest reality show controversy was *The Living Soap* (BBC, 1993–4) where students in Manchester were put together into a house for a year. It became a cause célèbre as various students complained about the pressure to 'perform' and the 'experiment' was halted. Today this would probably not be an issue as audiences and participants expect performances.

Channel 4 found that *Big Brother* fulfilled its remit for innovative television *and* attracted its target audience. Initially it was scheduled for the late evening but after word of mouth had worked it was re-scheduled to prime time (9 pm post-watershed). New variations on the format are constantly required in order to keep it fresh. The *Big Brother* team suggest that after three shows the format needs to be re-jigged as audience figures have declined below a critical mass by then. This is why the Big Brother house is changed and the contestant mix is altered with each new show. By Series 10 in 2009 the viewing figures had declined to just over two million mid-week (see BARB figures) but it was still a lucrative show. In August 2009, Channel 4 announced they were not going to commission

Industries and Institutions

Big Brother after Series 11 in 2010. This leaves the *BB* option open for others such as Sky or Channel 5 to buy. It will mean that Channel 4 will have to find a new format to fill this huge gap in its schedules and its budget (www.newsvote.bbc.co.uk/ 'Big Brother to Bow Out Next Year', 26/08/09, accessed 27/08/09).

Shows are only produced if they attract sufficient audiences to be profitable for sponsors or advertisers and attract returning audiences over a relatively long run. Thus the schedules need to provide commissioners with evidence of performance and for this the statistics from BARB are most useful. *Big Brother* for example has been successful in the summer period for Channel 4 as it can be fitted into the season when people are more generally outdoors but can catch up relatively easily through various other means than the evening broadcast. BARB's figures for Channel 4 in 2003 showed *Big Brother*, *Wife Swap* and *How Clean is Your House* as the top three shows. Channel 4's core audience of 16–34-year-olds were also viewing *Property Ladder* and *Grand Designs* (eighth and ninth). Channel 4 has been hit both by the slow down in advertising revenue and the attractions of new technology particularly for the young audience, but reality shows are still their top earners. In the final week in August 2009 included in the top 20 for Channel 4 were: *Location, Location, Location* at number one whilst 2nd to 8th were the *Big Brother* shows which also took 10th and 15th positions; *Come Dine With Me* (11th, 13th, 14th, 16th and 17th) and *Property Ladder* (12th) were the other reality shows in the top 20 (www.barb.co.uk, accessed 04/09/09). Reality TV has provided an anchor genre and attracted the young 'light viewers' sometimes referred to as 'elusive light viewers' (ELV) because they are heavy users of other media. What *Big Brother* did was to get these lucrative viewers to engage through technology and therefore they could more easily sell advertising slots. Andy Duncan C4's chief executive at the time of the furore over the racism row in 2007 stated that 'there are important creative and tonal challenges about where *Big Brother* goes next' (*The Times*, 27

Britain's Missing Top Model, far right

January 2007) but he went on to say, '…any talk of dampening down controversy runs the risk of killing [a] programme, which delivers an estimated £70 million advertising revenue' (Sabbagh and Sherwin, 2007).

The BBC paid for by the licence fee and with a remit to inform, educate and entertain also uses the reality format. Look at the following from the BBC commissioning website: (bbc.co.uk/commissioning/tv/network/genres/factual_features.shtml, accessed 31.03.09)

What's been working well? On BBC ONE, *Rogue Restaurants* was a tremendous success due to its combination of real consumer journalistic content and cheeky personality. On BBC TWO, *Mary Queen of Shops* turns fashion retail into great entertainment – a dedicated, passionate expert, real transformation, and a fresh perspective behind the scenes of a familiar subject that brings a younger audience to the channel.

On BBC THREE *World's Strictest Parents* is brave and entertaining, taking a revealing look at modern parent-child relations without ever sacrificing 'must-watch' entertainment values. Fearlessness is a great attribute for formats on THREE – *Britain's Missing Top Model* asks compelling questions about fashion and disability.

The classic structure of terrestrial television is to have a divided day with breakfast time; day time;

NOTES:

tea-time; early evening peak and evening peak; post 9 pm watershed and late evening followed by night-time. Most shows which might contain bad language for example, such as *Big Brother*, are scheduled after 9 pm.

These comments from the BBC website about the audience for the day time and early peak audiences show how they target their audiences:

> BBC Commissioning advice for Daytime and Early Peak television: Ideas need to have breadth. They must play equally well with a retired postman and a stay-at-home mum. We have a 40% male audience so ideas that alienate men are unlikely to be commissioned.
> (www.bbc.co.uk/commissioning/tv, accessed 31/3/ 2009)

Background to the Medium

The multi-channels and digital formats are changing the way audiences consume the medium.

Television began in 1936 in Britain. After a brief break for the Second World War (1939–46) it became the dominant mode of mass communication for many people in the second half of the twentieth century. Today it has broadened its reach to include niche audiences through cable and satellite channels and broadband audiences. The medium's power is not only that it is available to most people in developed countries, but also it has a global reach with satellite, digital and other new technologies being available in all continents. The concern about its power was evident from the start in that it was always a highly regulated medium. Even when commercial television began in 1955 in the UK it still had to follow a public service remit with educational and informational programmes as a compulsory part of its schedules.

One of the factors that led to the popularity of hybrid forms such as fly-on-the-wall approaches as in *The Living Soap* (BBC, 1993–4) and *Soho Stories* (BBC, 1996), was tighter budgeting because these shows did not require such intensive research or expensive locations and fees. Annette Hill quotes the cost of an hour long drama as $1.5 million (£875,000) per hour and reality programmes as $200,000 (£114,000) per hour (Hill, 2005: 6).

As a medium it represents a reality in terms of our senses as we can see and hear what appears to be a 'window on the world' through which we observe other realities. We may know that everything is constructed from choice of camera focus to editing sound, however knowing and

intellectually engaging with this knowledge whilst we are watching is a different matter. An innovation was the *Video Diaries* series where individuals filmed accounts of their lives or of issues with which they were involved with minimal professional editing.

Measuring Audiences

Television or its other viewing locations are usually small screen VDUs for domestic/personal use. It is part of the daily routine, unlike going to the cinema for example. The television is often broadcasting even if people are not apparently taking much notice. It is just there, and in many homes, in every room. Researchers have observed people and their TV use and shown that often people do not watch a whole programme – they are doing other things, talking to others and so on. *The Royle Family* (BBC1) of course famously parodied this in the way it had the audience positioned as the television in the room as the family sat in front of it but taking little notice of what was happening on the screen

Television companies spend a lot of time and money tracking audiences to help them see how well a programme is doing but also to establish trends in viewing habits. As well as their own internal researchers they use BARB which provides unbiased data for the media industry. Commercial television needs to know not only how many people are watching but also who is watching so that they can deliver these audiences to advertisers and the BBC also needs to justify its use of the licence fee to prove that it is serving all the community not only a small elite. Viewing figures help to do this.

Terrestrial programme-makers and the scheduling departments of television need to know the type of audience they will attract, what their competitors are doing and if there are any outside events which might influence them. This is not so crucial for specialised digital channels. Television Rating (TVR) describes the size of the audience as a percentage of the relevant population group for that programme who watched. Ratings are important as they are used to indicate the success of a programme and how likely the format will be repeated, although this is rather a crude measure of success. It is possible that many people have tuned into a *Big Brother* episode because of a particular controversy or for voyeuristic reasons, as Andy Duncan chief executive said after the Goody/Shetty controversy, 'the tensions in the house had "been in one sense good television"' (Sabbagh and Sherwin, 2007), but that does not to mean to say the audience regard it as quality television or that they are likely to tune in again.

Industries and Institutions

Local and Global

Television is a global phenomenon. Changes in technology are of course changing the television world. Multi-channels and digitalisation are the two driving forces. This is both the cause and the consequence of globalisation and the synergy achieved by global companies. Ownership of channels and of gateways to the platforms which deliver these is a significant factor. These organisations have different agendas to providing quality television – and in any case whose quality are we talking about? How far does this globalisation make us a 'global village' (McLuhan, 1964) and how far does it homogenise cultures and impose external values onto native cultures? These large corporations need audiences to provide income and a diffuse audience fragmented over time and space is a difficult target. But some formats are globally successful.

One of the earliest programmes to be sold around the world was MTV's *The Osbournes* (first shown in the UK in 2002 on Channel 4) which followed the pop star Ozzy Osbourne and his wife, Sharon and children, Jack and Kelly and made stars of them all. It was one of MTV's biggest earners. Its initial three week run extended to three years and it proved the popularity of this format with the youth audience which MTV (and Channel 4) targeted.

Although we only maybe watch the UK versions of *Big Brother* and other shows they have a global reach through franchising which the independent production companies can do when they own the copyright to the material. Virtually every continent has its own version of *Big Brother*.

The transfer of these formats and shows across national boundaries are part of the globalisation of communications which creates a global consumer culture. A few large companies such as Sony, News International, AOL/Time Warner are globalised. However the transfer of formats is not a one-way traffic as often suggested by the cultural imperialism debate. British formats such as *Supernanny, The Apprentice* as well as *Pop Idol* have all been adapted for US television. Another UK show, *Wife Swap* (2004) achieved the highest share of 18–34-year-old women, the most valuable audiences for US television for their advertisers (Bignell, 2005: 39).

Regulation and cultural mores of course differ in different cultures. The *Big Brother Africa* (2003) had contestants from several African countries but was criticised by politicians and religious groups for being un-African and imposing western (im)morality. In the Middle East the show was pulled after allegations of un-Islamic practices.

There are other local factors such as how people from different cultures who are on television think they should behave. In Britain in the first *Big Brother* show some of the participants stripped off; in America they talked about sex but stayed dressed; in Holland they (probably) did have sex. In some Muslim countries these programmes were not broadcast at all. Both local regulation and the cultural norms of privacy played their part in each show.

However, in the main, Reality TV has shown that it can overcome these local difficulties and be a lucrative option in different cultures. In India in 2008 Viacom (a large media conglomerate) introduced a new Hindi channel called Colors. It reached number two in the TV ratings (where there are over 350 channels). To stand out from the soap dominated Indian television Colors had decided to go for the reality format: 'That was a gamble, since in India, unlike most places, soaps are cheaper than reality shows…' (Lakshman, 2009). Color first offered a show called *The Player of Danger* with a Bollywood megastar. This was followed by *Big Boss*, like *Big Brother* with 15 people living in a house for three months, and then a show similar to *American Idol*.

NOTES:

Regulation

Currently (2009) the regulatory authority in the United Kingdom is Ofcom for commercial broadcasters and the BBC Trust for the public service broadcaster. Both organisations are working within a constantly changing media world and both are relatively new. Ofcom arose at the beginning of the century in response to the need to regulate an increasingly convergent media world. The BBC Trust (2008) was formed more recently and replaced the Board of Governors which had been heavily criticised for their response to the reporting of the Iraq War. Ofcom was particularly involved with *Big Brother* when the racist issue was raised and also with reported sexual acts on screen before the 9 pm watershed.

> January 2007: Probe into *Celebrity Big Brother* 2007
>
> 'Ofcom receives nearly 45,000 complaints following the alleged bullying of a contestant. A full investigation is launched while programme is still on air and Channel 4 is later found to have breached the Broadcasting Code and has to screen a statement of our findings on three separate occasions.' (www.Ofcom.org.uk, accessed 29/3/2009)

From a regulator's perspective, these issues will influence thinking on content regulation in a digital world. The following is an extract by Ed Richards the Chief Executive of Ofcom made in a speech on 27 June 2007 about 'Developing successful regulation to support the future of British broadcasting':

'Today it's day 29 in the *Big Brother* house. *Big Brother* is a series which can have an important role to play in demonstrating how freedom of expression can raise matters of social importance, leading to legitimate public debate. But it can only achieve that with appropriate checks and balances in place and by avoiding the serious editorial misjudgements we saw early this year in the Shilpa Shetty case. *Big Brother* is also a great example of the range and variety of content available today and the problem that causes for content regulation.'

It's not easy being *Big Brother*'s big brother:

He went on to say:

'• I can watch it on my television on Channel 4 or on multi-channel on E4 and E4 + 1 regulated by Ofcom.

• I can pay to watch it live on-line and unregulated on the Channel 4 website or on Four on demand.

• I can download video clips on-line, unregulated.

• I can watch video clips on my mobile phone, which is self-regulated.

'It is quite a challenge trying to explain this logic to an average member of the general public. So, as far as content regulation is concerned I see the recent agreement on the AVMS directive as a sensible evolution of the current model. *But it's likely to be only a stepping stone on a journey, because it's far from clear that the current settlement represents a long term sustainable solution to the future of content regulation. As the lines between different technologies blur further, the calls for a regulatory system which adapts to the emerging digital reality may well grow stronger.*' (ibid., my emphasis)

You could research the regulators opinion on accuracy by looking at Ofcom's website, www.ofcom.org.uk/tv/ifi/codes/bcode/ and Section 5 'due impartiality and accuracy' where you will see some of the principles governing commercial television and factual programming.

The BBC's Guidelines can be found at www.bbc.co.uk/guidelines/editorialguidelines/ click on 'accuracy' (accessed 31/03/09).

> The introduction states:
>
> 'The BBC's commitment to accuracy is a core editorial value and fundamental to our reputation. Our output must be well sourced, based on sound evidence, thoroughly tested and presented in clear, precise language. We should be honest and open about what we don't know and avoid unfounded speculation.
>
> For the BBC accuracy is more important than speed and it is often more than a question of getting the facts right. All the relevant facts and information should be weighed to get at the truth. If an issue is controversial, relevant opinions as well as facts may need to be considered.
>
> We aim to achieve accuracy by:
>
> • The accurate gathering of material using first hand sources wherever possible.
>
> • Checking and cross checking the facts.
>
> • Validating the authenticity of documentary evidence and digital material.
>
> • Corroborating claims and allegations made by contributors wherever possible.'

Industries and Institutions

Under 'Reconstructions' it states:

'In factual programmes reconstructions should not over dramatise in a misleading or sensationalist way. Reconstructions are when events are quite explicitly re-staged. They should normally be based on a substantial and verifiable body of evidence and be labelled as reconstructions. If unlabelled they should be differentiated in some way from the visual style of the rest of the programme such as using slow motion or black and white images in a consistent and repeated way.

News programmes should not generally stage reconstructions of current events because of the risk of confusing the audience. But reconstructions staged by others may be reported in the usual way.'

So the BBC is aware of the way that fact and fiction can be manipulated. For all broadcasters this concern is within a context of new media and financial strictures. The BBC is funded by the licence fee which has meant it has not been affected directly by the vicissitudes of the advertising cake. But it cannot avoid being affected by the new structures. Channel 4 is looking to have help from the BBC by joining with part of it or taking some of the licence fee. Although this has been strongly re-buffed by the BBC this is still (2009) in the pipe-line, whilst media watchers are debating whether terrestrial television and public service broadcasting can survive at all.

In the past television worked as a public space or in Habermas's (1989) term 'the public sphere' in which debates and issues could be aired, a sort of media village pump. Nowadays this public function is less clearly seen as multi-channels and fragmented audiences change the post-modern media landscape.

Conclusion

As the above quote from the Chief Executive of Ofcom shows it has to face the new world of modern communications and it is treading a tightrope between the needs of the commercial companies and the belief in public service broadcasting which has been the cornerstone of broadcasting in this country since 1927. The public service broadcasters believe that their freedom from commercial constraints means they can focus on being innovative, providing for minority groups, achieving universal access, providing a space for public debate, education and achieving quality. The BBC has a world-wide reputation which may be lost if it has to rely on commercial funding. There is the counter argument that those who want all these things should pay for it whilst those who don't can subscribe to other providers. However commercial broadcasters want the freedom to exploit all sources of revenues to stay in business. Some commentators see the combination of commercial and public service broadcasting as important as it provides both a sounding board for general taste but also commercial acumen. Commercial television it claims gives consumers choice and is more democratic in that the companies will respond all the time to the needs of the audience (see James Murdoch's attack on the BBC and regulators in Douglas, 'Murdoch Sparks Talks on TV Future', www. bbc.co.uk/1/hi/entertainment/, accessed 02/09/2009). Others suggest that commercial factors mean they will mostly go for the cheaper format. We have seen this before as in 1997 when the ITC (fore-runner of Ofcom) severely criticised ITV for its poor showing in documentaries which had been replaced by docu-soaps. This leads us to the social and cultural debates surrounding these types of show to be discussed in Chapter 7.

NOTES:

Activity 16 – Track a Reality TV Show

Aim: To follow the marketing of a reality show and how it builds an audience.

Objectives: To observe intertextual and cross media links.

Either as a group or as an individual, look out for and collect all the ways a current reality programme appears around you – Internet blogs, newspaper articles, magazines, mention on radio shows, TV chat shows, guest appearances and so on.

Write a report using your results to include the type of show; its target audience; its key messages. Make sure you refer to as many examples of marketing as possible to use as evidence for your conclusion.

Student Activities

Activity 17a – Scheduling

Aim: To show how important scheduling is for the producers.

 ↘ Teacher: Collect as many schedule lists such as the *The Guardian* Saturday Guide; *Radio Times,* etc. for use in this classroom activity, or have access to schedules on websites for working in pairs.

In 2004 in one season there were at least two of the following programmes on every day:

Interactive Programmes

I'm a Celebrity… Get Me Out of Here!
Fame Academy
Shattered (a group of young people on a house had to stay awake for a week)

Makeover Programmes

Changing Rooms
Faking It
Celebrity Fit Club
A Place in the Sun
Relocation. Relocation

Fly-on-the-wall Documentaries

Boss swap
Club Reps
Airport
The Salon
Learner Drivers

Is this still the case? Primary research will tell us:

- Look at the terrestrial schedules over one week.
- List reality TV shows on one week's schedules. You can either use similar categories as above or create your own such as docu-soap and docu-game.
- Note: channel, day, time of day. (N.B.: This could be set out as a chart to help you collect the data.)

Broadcasters usually divide the day into segments such as:

Breakfast time 6–9 am.

Day time 9–3 pm.

Tea-time 3–6 pm.

Early evening prime time 6–9 pm.

Late evening prime time 9 –11 pm.

Late evening 11–12 pm.

Late night 12–6 am.

Having collected your data, answer these questions:

1. Which channels are heavy/light users of reality shows?
2. On which days are most shown?
3. What time of day are most shown?
4. What differences are there between channels?

 a) If you complete this activity over a series of weeks you will be able to compare your results with 2004. Are there more or less reality shows today?

Extension Activity: Write a report for a newspaper using the statistics you have researched.

Title: 'Are Reality Shows taking over Television?'

Remember to consider the target audience for the paper – it could be a student paper, a local paper or a national paper. Use these questions to help:

- Is there a pattern in scheduling across the week?
- What is the percentage of reality shows in each time slot?
- What conclusions can you draw?

Student Activities

Activity 17b – Channel Identity

Aim: To show that each channel has a particular target audience.

Objectives: The use of visual icons.

The understanding of idents.

The use of channel websites for research.

- Match the identity of these characters with the terrestrial channels BBC One and Two, ITV1 Channel 4 and Channel 5.

All images © www.istockphoto.com

Write a short, synopsis of what each might see as their channel identity.

Hint: Look on the channel website and watch the ident trailers for the channels.

To help here is the factual features and formats BBC guidelines for commissioning from the BBC website:

Features and formats are naturally excellent at bringing younger channels to the BBC, and play an important role in doing so across BBC ONE, TWO and THREE.

Always entertaining and accessible, formats on ONE should change everyday lives for the better, giving people empowering ways to view life.

Formats on TWO should break new ground to appeal to 25–44 year-olds, whether it's bringing different perspectives to established subjects – or finding authentic but entertaining ways to explore otherwise complex areas.

Features and formats on THREE continue to blaze a trail of originality and bravery for an audience of 16–34 year-olds hungry for new ideas, without ever losing sight of the their cheeky, provocative view of the world. They are often driven by compelling real-world questions and always, always deliver high entertainment values. www.bbc.co.uk/

Activity 17c – Which Channel?

Aim: To test that the channel identities are understood.

Objectives: To combine word analysis with channel identity.

To understand how language use has meanings.

➤ Teacher: Photocopy the list of titles.

Here is a list of factual programmes broadcast recently.

From the title and your own knowledge – can you say which channel they might be on?

Programme	Channel	Were you right or wrong? ✓/x
The Sky at Night		
Animal Park		
Real Rescue		
The Department Store		
Great British Menu		
The Car Show		
Countryfile		
Country Tracks		
Britain's Got Talent		
TVs Naughtiest Blunders		
Celebrity Chefs in Trouble		
60 Minute Makeover		
The Biggest Loser		
You've Been Framed		
The Real Swiss Family Robinson		
Shipwrecked		
Country Tracks		
Trisha Goddard		
Zoo Days		
Michaela's Zoo Babies		
SuperNanny USA		

Student Activities

BBC1: *Country Tracks, Countryfile, The Sky at Night, Real Rescue, The Real Swiss Family Robinson, The Department Store*

BBC2: *Great British Menu, Animal Park, The Car Show*

ITV1: *Britain's Got Talent, TVs Naughtiest Blunders, Celebrity Chefs in Trouble, 60 Minute Makeover, The Biggest Loser, You've Been Framed*

Channel 4: *Shipwrecked, Supernanny USA*

C5: *Michaela's Zoo Babies, Trisha Goddard, Zoo Days*

Extension Activity: What conclusions can you draw about the target audience for each of these groups? Use evidence from the lists to back up your points.

Activity 17d – Media Diary

Aim: Primary research on television use.

Objectives: To complete own research.

To understand producers/audiences are symbiotic.

↘ Teacher: Prepare a diary sheet for students to fill in or a master one for them to copy.

Investigate how you, your friends and family use television during the day.

Ask them to keep a media diary for one typical day, e.g set out:

Day: Monday Tuesday

6.30–9 am Breakfast show ITV

 Whilst eating

9–12 am

- Do you notice any particular patterns of viewing that would help you schedule a new reality show on a particular channel at a particular time?
- Give your reasons and evidence from your research.

Student Activities

Activity 18 – Research Questions

Aim: To encourage research techniques.

Objectives: To get students to use a variety of resources.

To encourage self-directed study skills.

➘ Teacher: Put questions up or print out for individual or paired work; prepare a library booklist or have books available in class, and a website list (see references) which you feel might help their research. Emphasise that 'Googling' will give them many sites which are inappropriate.

Each of these questions requires research. Use the work you have done so far plus extra research to write a report in answer to the question you have been allocated.

- **How do television broadcasters decide what to broadcast and when?**

 Hint: Different audiences, audience research, targeting, watershed – BARB.

- **How do broadcasters decide on their schedule?**

 Hint: Consider both the selection and the combination of programmes, times, other channels, schedules in listings magazines target audiences.

- **Find out about independent television production companies, what do they produce, for which channels? Why are global sales important for these companies?**

 Hint: Look at the credits at the end of a reality show and look on websites of different production companies. Choose a few to study in more depth. How do they develop programmes?

- **What happens in the different stages of producing a television programme?**

 Look at development, pre-production, production, post-production, publicity/marketing.

 Hint: Think about what you would need to do for each stage. Look at production company sites. Read about production in Media Studies textbooks.

- **What is the difference between commercial television and public service television?**

 Hint: Ownership, funding, regulation, remit. Look in Media textbooks and on-line sites such as www.mediaknowall.com.

- **What is public service broadcasting? Why is there a debate about this in Britain today?**

 Hint: John Reith, the BBC website, government sites, Media textbooks and websites.

- **Who runs the commercial terrestrial television channels? How are they surviving in the new media world? What is their future?**

 Hint: Look at ITV plc for C3, Channel 4 and RTL and UBM for 5; research newspaper sites such as *The Guardian* and current affairs programmes.

Extension Activities: Find out who owns the cable and satellite channels in the UK?

Discuss: What do you think is the future of television in the digital world?

Chapter 7 Debates – 'Fakery in allegiance to the truth' (Head of The Times' organisation, 1935: 7)

Having read Chapter 7 you should be able to:

- Identify the difference between criticism of Reality TV such as faking, and critical debates which surround this genre such as celebrity culture.

- Understand issues of representation of groups and institutions.

- Consider how real is real in reality television.

- Debate whether the media empowers us or reduces us to couch potatoes and computer zombies.

⇒Activities 19-22

There are many debates surrounding Reality TV including: privacy, truthfulness, accuracy, persuasion, bias, manipulation, selection, censorship, dumbing down, realism, celebrity culture, representation and popular versus high culture. The following looks briefly at some of these debates.

The media has often been the prime suspect for many of the ills of society, whether moral panics, sleaze, spin, moral decline and dumbing down and much of the most recent focus of this debate has been around 'celebrity culture' and 'reality television'. In today's media savvy world the reality which was observed in the 1974 fly-on-the-wall documentary *The Family* (Paul Watson) has given way to the contrived situations such as *Wife Swap* (Channel 4, 2003–) and it has become almost impossible to capture anything like a natural response from participants:

> 'Everyone knows what is expected, how it will look, what the programme-makers are up to. To be confronted by a camera, inside or outside, is an opportunity to perform and to make a mark.' (Nick Clarke in Keighron, 2003)

Playing up to the camera is not new. A quick look at some of the Mitchell and Keynon (BFI DVD, 2005) films of the early part of the twentieth century in the North of England will see much performance from ordinary people when in front of the camera. Even in the first cinema film the Lumière workers appear to dress and play up to the camera as they come out of the factory gate (*Sortie d'Usine*, 1895). However with the media saturation today there is a subtle change in the way we view society as a result of seeing ourselves on the 'screens' and being able to access and produce our own versions of reality.

Video Diaries to Internet Diaries – Who is in Control?

Today groups such as politicians, teachers, police, social workers, bankers, teenagers to name just a few, are shown 'performing' their real lives in front of the camera or can be found in other media such as 'twittering' on the Internet. There are two views on this: one sees the media as the way the world is, being reflected and reacting to the issues around; the other sees it as manipulating and mediating so influencing the beliefs about society which may then distort our response and feedback into the real world by creating a hyper-reality. In other words the new technologies can either offer up the opportunity for democracy or put control in the hands of a few media and their moguls.

In the very early years of the new phenomenon of audiences becoming producers, *Sight and Sound* asked the question: 'Are video diaries wresting power from the broadcasting professionals?' (Keighron, 1993). In 1993 video was still in the vanguard of the technological revolution. Even at this early stage there were different show formats. One early version of recording a reality show was using hidden cameras such as *Candid Camera* and *You've Been Framed* where unsuspecting people including celebrities were set up in situations and their reactions were used for entertainment. A different format was the video diaries which had originated in the public access programmes where viewers were allowed to present opinions about certain issues: 'Video diaries,' said Roger Graef (a celebrated documentary maker), 'is the most important development in television probably since the hand-held camera itself' (ibid.). The non-professional having shot the footage the key question was then who had editorial control? How far was the integrity of the material maintained? How far did audiences believe that a video diary format was truthful? Today there is the suggestion that we are all now 'citizen journalists', video diarists, posting our mobile phone pictures onto websites and twittering about events as they happen. However truthfulness and authenticity are still key issues.

Debates particularly around Reality TV are often based upon their claim to authenticity. Are the participants authentic? Are the situations authentic or constructed? Are the experiences, emotions, reactions we see authentic or false? Or are we entering an exhibitionist and confessional culture TV constructed for entertainment? How fair is the representation of the participants? How much editing is done to create a drama? Even in

Debates

the *Big Brother* house cameras are on all the time but a selection is made by the editors and the participants know they are performing.

Regulation: Taste and Decency

Some of the appeal of reality TV is that it can be on the edge. You are not quite sure if bad language or bad behaviour will move from the acceptable for entertainment to the offensive. The suspense and lack of certainty, the potential for a faux pas all add to the interest for the viewer. Controversy has been one of the key factors in the publicity surrounding *Big Brother* and other shows. Mostly the rules are met and the watershed is observed. But with a 'live' reality show there are always pitfalls. The BBC has its Producers Guidelines and Ofcom has rules for the commercial stations. However the audience and context are important. A young audience for example is more likely to accept bad language and bad behaviour. The fight on *Big Brother* in 2003 when security guards were sent in to break it up was being streamed live on E4 at the time and the broadcast was suspended for an hour. Although it resulted in complaints to Ofcom, because this was on a specialist channel where audiences purposefully went to watch it, the incident was not seen to be as serious by Ofcom as a later similar one seen on terrestrial television.

In the context of a live show the odd expletive may be acceptable to general audiences. But the incident with Jade Goody and Shilpa Shetty in *Big Brother* (January 2007) where bullying and racism were accusations made about some of the participants, shows the point where the audience felt that there had been a breech beyond acceptable behaviour.

Here the broadcast context was terrestrial not a specialist channel and the complaints were viewed more seriously by Ofcom as a breech to its code. There was also a suggestion of legal repercussions. As a result the producers initiated a slight delay on live broadcasting so that they can bleep out any offensive remarks. (Many of these controversial episodes can be viewed on YouTube.)

Celebrity

Reality television has made celebrities, some very short-lived, out of many of its participants helped by gossip in the press and magazines. The talent shows have enabled some to build upon their abilities, whilst the docu-games and docu-soaps have produced temporary celebrity status to a few of their participants, sometimes called 'Z-list celebrities':

> 'Celetoid…any form of compressed, concentrated attributed celebrity…the accessories of cultures organized around mass communications and staged authenticity.'(Turner, quoted in *M/c Journal* vol. 7, no. 5, 2004)

Celebrity culture is said to be the 'zeitgeist' (spirit) of the times. It is seen as significant because it appears to have established new cultural values not present in previous periods. Depending on your view it can either be a form of democratisation or a symptom of cultural decline.

Jade Goody and Shilpa Shetty, far right

NOTES:

Richard Dyer discussed the star system of the classic Hollywood period as being part of the industry's raw material, a commodity to be shaped as part of the product. This analogy can be applied to the celebrities of consumption such as the participants of Reality TV who are used as a commodity. In return the Reality TV show offers the opportunity for some to 'make it', both financially and in status, often without any real talent or work.

Certainly the idea that celebrity is all encompassing in today's popular culture is a significant part of the debates around Reality TV. For ordinary people the new technologies appear to have democratised the media by increasing access to it in order to have their, in Andy Warhol's famous phrase, 'fifteen minutes of fame'. This is certainly one broadcasters and producers favour. You can for example find out about some of the past participants of *Big Brother* on the *Big Brother* website and other sources, such as Allen, 'BB through the Years', www.newsvote.bbc.co.uk/, accessed 27/08/09) and discover how they have carved out minor media careers. Not only ordinary people but also B list Celebrities appear in a range of reality shows for all sorts of different reasons: such as to kick start a failing career as with Ron Atkinson appearing in *Celebrity Wife Swap* in August 2009; or to signify a change in career direction; or just to make money.

As already mentioned there are two opposing views to this celebrity culture. One view is that the system of a market-led economy is the driving force for democratisation. In Reality shows like *Big Brother* (C4) and *Pop Idol* (ITV) the audience is the judge and jury and can choose the winner through voting power. *Pop Idol* (ITV, 2002) led to the careers of winner Will Young and runner-up Gareth Gates. Talented individuals have also been given access to forums through the Internet where they can at least have a chance to become a celebrity, whilst ordinary people can become overnight 'stars', such as Jade Goody on *Big Brother*. If they are clever enough or have some form of talent they can exploit this window of opportunity and become more than a 24-hour wonder for the gossip magazines. It can of course backfire, as with the case of Susan Boyle on *Britain's Got Talent* 2009.

So in this view celebrity culture is a positive democratisation of society. The power of the media is within the hands of the people and gives the opportunity of fame and acknowledgement of their worth to people for just being themselves. This is certainly the view that is marketed on websites and by publicists. However, is this a fig leaf hiding the vested interest of having a good supply of stories and gossip to feed the media's voracious appetite, or do they really believe it's about democracy?

The opposing view is a political economic viewpoint. From this perspective there is no real democracy in the media which is controlled by those who own it. It uses the desire to be famous to sell the products or to divert attention away from real social issues. This viewpoint sees the celebritisation of popular culture as evidence of a cultural decline. It identifies the widening of the definition of celebrity and the inclusion of people possibly with only a talent to be noticed as indications of a social change in which people want success without the work attached to it. These commentators see a society that is fuelled by the desire for instant gratification. They also see that the public sphere of debate has been eroded and that the private, such as how to dress and to behave, as in makeovers, now inhabits this space. Politicians are given celebrity status and the margin between their public and private lives are eroded. In April 2009 the then Home Secretary, Jackie Smith, was having a tough time regarding adult videos her husband watched and the claim for these on expenses. In terms of the cultural decline view the news values which were being used by news organisations wasn't really the claim on expenses (which was only a few pounds) but the inside view of a relationship. In addition the power of celebrity to sell magazines and other products means that the celebrity has the ability to exert power over the media. They can manipulate it to their requirements. This is helped of course by publicists such as Max Clifford. (Clifford is one of the best known publicists used by many stars and was the 'voice' of Jade Goody to the media and therefore the public in her last days and has been used by Susan Boyle). In this counter argument to the view that the media only provide what the audience want, it is the economic base controlling the cultural content.

So in Reality TV terms:

• Celebrities are seen as having fame for being famous which has taken over from talent and hard work.

• Celebrities are seen as victims of the manipulative power of the media (its owners, publicists and producers).

• Celebrities are commodities from which to make profit.

• Celebrities are victims of the voyeuristic audiences who consume them.

• Celebrity is now accessible to all; it shows how democratic the media have become.

Debates

Representation – reflection or construction?

Understanding that the media constructs views about society leads us to an important critical debate in Media Studies, that of representation. People, institutions and places are open to representation and stereotyping. Stereotyping is used as a short hand for meaning. It takes easily recognisable and usually negative characteristics and uses them repeatedly to signify the group. This can be conveyed by dress codes, non-verbal communication or other signifiers. It is reinforced by repetition of the same message in different media creating a discourse. Nothing is neutral – choices are made, points of view are seen – and all influence the message. This then delivers beliefs (ideologies) which suggest the status and power relationship between groups. The repetition of these simple ideas makes them appear natural, everyday and truthful.

How far do the producers of reality shows use stereotypes? In the docu-soap about driving tests the unfortunate Maureen seems to me to play to the much quoted stereotype of 'women drivers'. (In fact women get cheaper insurance premiums as they are less likely to have accidents than men.) The choice of participants in any reality show is not neutral. The use of stereotypes is part of the process of selection in shows such as a docu-soap or docu-game. Even in the earliest docu-soap *The Living Soap* (BBC1) the students were selected to 'represent' different groups such as the middle class; the broken home; the stud. Other reality shows have picked up people who have become representative of particular types, such as Jeremy in *Airport*. Talent shows seem to be able to find some very untalented individuals, who can be viewed as 'types' when they briefly appear during their auditions.

In docu-games such as *Survivor* and *Big Brother* participants are often chosen to represent a group. The Big Brother House tries to pick 'types' such as the ethnic minority; the mouthy bitch; the unemployed. When she first appeared

Jade Goody fulfilled the stereotype of 'Essex Girl'; someone who was loud, uneducated, only interested in making an impact however crude. Her working-class background was combined with her gender by the news media to create a discourse of condemnation for the values she represented. This in fact backfired as their readers found Jade natural, authentic and representing their values. Her background of family drug abuse and her climb out of this situation via a reality show captured the public's imagination. The tabloids did an about-turn and began to represent her as 'triumph over adversity'.

Place can also be represented. The types of area where police shows are frequently filmed, such as city centres, housing estates all become representative of the idea of 'crime' and disorder. This can create a fear or 'moral panic' within the viewing public who may see such places as dangerous, even if most are perfectly safe, because of the way they are shown in the media. Hospitals, schools, villages, islands have all been represented in reality shows and often reflect stereotypical views. Nationalities and regions are also often represented through a 'short hand' of received knowledge. Even in the United Kingdom which is relatively small there are regional and country stereotypes, such as the Geordie, the Brummie, the Eastender, the Scot, the Welsh and so on.

Representation in the media is a powerful means for creating beliefs and it is the repetition and the frequency with which it is used which help to build up the beliefs about groups. No image is neutral. The angle of the camera, the lighting used, the sound track and words used all help to build up meaning. Race, age, gender, ethnicity, class, region are all open to (mis)representation and on reality shows how people are represented can have considerable repercussions for good or for bad.

Key questions to ask are:

• Who/what is being represented?

NOTES:

- Who is doing the representation?

- For whom are they producing this representation?

- Who is reading the representation?

- What effect/meanings does this representation have?

Realism

'Real life… to happen more quickly … guarantees you get real drama.' (Hinks, in Biressi and Nunn, 2005)

As the term Reality TV indicates the concept of realism is at the core of these programmes. The relationship between the media and realism is a complex one and plays an important part in the audience's understanding of this genre, and as with representation with which it is closely linked, how reality is selected and constructed, by whom, for whom and what messages are conveyed are basic questions to ask. The media presents us with a view of the world, but aren't we all different? We may accept some commonalities but we also have a personal view of the world. That's why media analysts will sometimes talk about 'audiences' rather than 'the audience'. This means that there are as many versions of reality as there are people viewing. However we do have some common understandings, such as cultural knowledge, and this is what the media uses to construct a dominant reading.

So what do we mean by realism in the media? Realism is always constructed through form and content and by media language and codes:

Realism and Form: A scene is constructed through camera and editing and other elements to build up a belief in the audience that they are witnessing 'real events' even if it is set in the future or the past. The actual form depends upon the genre. For example soap-operas use shot reverse shot in conversations, in action films a travelling shot may be used, whilst the 180 degree rule means that we are always positioned by the camera in the same point within the scene. Motivational or continuity editing makes us follow the interaction as believable and 'real' – cause and effect. Another form of 'poetic realism' may use montage editing to create an anti-realist effect but one which has an emotional or intellectual reaction for the audience (the shower sequence in Hitchcock's *Psycho*, 1960 being a classic of the emotional and Eisenstein's Odessa Steps sequence from *Battleship Potemkin*, 1925, for the intellectual). It invites the viewer to take a position from which to read and to understand the events on-screen.

Realism and Content: Realism is also about the look and *mise-en-scène* of a text. The costumes, settings, the objects and so on have to fit with our notions of what would be seen and how people would behave. A character in a drama set in the nineteenth century would not be wearing a modern wristwatch for example. Even in 'unreal' science fiction – which may have elements that might become true, the 'what if…' syndrome – there has to be a sense of how we expect scientists or others to behave in certain circumstances. They must fit into our notions of reality if we are to accept the narrative's cause and effect.

Reality TV uses forms from factual categories such as non-actors, unscripted, real time and ties them into fictionalised or constructed situations, such as the Big Brother house and so the boundaries become blurred.

Thus realism and media languages are inextricably linked. Language constructs our social interaction and our view of reality. The type of shot, the angle, the order and juxtaposition of images/sounds are motivated acts. The selection for editing even with direct cinema or fly-on-the-wall technique means that a mediator comes between the viewer and the subject and they shape the message. This is done through media language such as where you position the camera, the angle; sounds including the type of music; editing effects, for example by cutting out parts or putting different images together; lighting issues, for example lighting of different coloured skins.

Some texts have a stronger relationship with reality than others. Films of the British New Wave represented the working class, used natural dialogue, setting scenes on location which all added to the 'social realism' mode of address. More recent exponents have been directors like Ken Loach and Andrea Arnold (*Red Road*, 2006 and *Fish Tank*, 2009). This differentiates them from classic realist texts which concentrate on the surface detail of style and the classic narrative structure. Generally these codes are not mixed and maintain and conform to our expectations of particular kinds of realism. But when mixed the fact and fictional codes have created strong audience responses as with the famous Orson Welles' radio broadcast on 31 October 1938 of *The War of the Worlds*. Welles presented this nineteenth century story using the conventions of a contemporary radio news story which resulted in panic in the audience who believed they were really hearing a Martian invasion.

On television this genre mixing with drama-documentaries challenged audiences in the 1960s and 70s with the social and political discourses they conveyed. *Life on Mars* BBC1 (2006–7) was an example of mixing conventions or modes of

Debates

realism for entertainment which created almost a sur-realist text. Hybridity and mixing are all part of the changes in generic form as well as part of the continuities that help audiences to make sense of these forms, but they all rely upon our understanding of a constructed reality.

If we consider there is more than one version of reality, what types of realism do the different reality shows reveal? A window on the world (naïve realism), or a mirror reflecting our own views of the world (constructionist realism), or the media getting closer to the real truth through interpretation (critical realism), or a social realism but revealed through fictionalised accounts, or sur-realism breaking rules both of form and content.

In our own lives there is a continuum of reality from our own experiences to the way we interpret these experiences, through to the sur-real world of our dreams. We can use our knowledge of the real world to make sense of the fictional one. Even a vampire or a science fiction film has a relationship to the real. Characters act in a motivated way when faced with a vampire, and the *mise-en-scène* appears to be truthful to the genre. So we recognise the conventions of a space ship even if we have never seen one. But some media texts make special claims to being real, as with a documentary. We expect, for example, that people in a documentary do not just look and act real, a surface reality, but are real.

Even when the term documentary was first coined and described as 'the creative treatment of actuality' (John Grierson), it was acknowledged that maybe there is a greater truth to be revealed beyond what is seen as a window on the world, through different styles, such as a poetic, reflexive or a didactic exposition, although still reflecting a reality. So is realism as simple as fictional equals not real and factual equals real? No! People who make documentaries or other forms of factual television are creating a version of reality. Their version of reality is an interpretation influenced by many things. This means that television realism is always ambiguous. Things may look

real but are always mediated.

In addition reality as constructed through the medium is a creation which can have real consequences. We can believe for example that a particular group is 'really' scrounging off society because of the way that they are repeatedly presented. This is how Cohen (1972) suggested moral panics are created.

Realism and Ideology: What the media do is to construct and to repeat ideas and beliefs about the world. These create a 'knowledge' and an apparent truth or reality for audiences. This is how stereotyping works. It corresponds to the way the world is perceived. These discourses coalesce to make a discursive formation (Foucault). Ideology according to Althusser (1971) is not a set of static beliefs but works through practices, such as in Reality TV, making sense of the world for us:

> 'Once the "real" is established…it becomes a vehicle for the communication of messages which embody, not our "real" social relationships, but rather cultural mythologies about those relationships.' (Fiske and Hartley, 1987: 170)

So if reality is constructed how far is Reality TV a construct?

- It has unscripted dialogue.

- It uses hand-held cameras.

- There is the sense that the camera is merely recording what is happening.

- It uses real locations.

- It has real people.

- It claims to be authentic.

- It does not montage edit and uses real time.

- It has a sense of the present, of being 'live', of the here and now, even if recorded.

- It is not like constructed drama, or the news.

So could Reality TV claim to have challenged Fiske and Hartley's claim about relationships? As

NOTES:

ever with this 'amoebic' genre there is no simple answer.

Realism and Audiences: There are different levels of realism under the Reality TV umbrella. A docu-soap based upon real workplaces such as an hotel, an airport, a hairdressing salon allow us to enter into the 'real' world of real people, both public and private. However a docu-game such as *Big Brother* is contrived. The set is constructed and the relationships manipulated through audition and selection. But its appeal is because there is a belief that participants are behaving and responding to events as ordinary people would do in similar circumstances. Contestants are given short-term goals, mini-crises and are being appraised. Here of course the appraisers are nationwide not work colleagues or friends. We feel that there is a revealed reality about human behaviour in what is being exposed in the experiment inside the house. So *Big Brother* generates its own hyper-reality created with artificially designed rules and scenarios but it is still seen as representing a form of reality to the audiences because the contestants can choose how they respond. They are seemingly in charge of creating their own persona.

However it is clearly edited. The first Australian *Big Brother* edited 182,750 hours down to 70 hours of television. There is also a built in delay to avoid any contravention of rules and codes. The show's producers also ratchet up the tension by introducing more and more unpleasant tasks: 'The levels of intervention from us increase as the show progresses – we have to find creative ways of making the experience different' (the Creative Director, quoted in Sparks, 2007) and as *Big Brother* has developed it has moved away from a pseudo reality towards performance:

> 'Realism is thus defined by the way it makes sense of the real, rather than by what it says the real consists of' (Fiske, 1987: 24).

This making sense involves actively participating and today this is a physical as well as a mental interaction. We actively maintain the dominant view although occasionally there is a crisis in the hegemonic balance of power. The Channel 4 docu-soap called *Flatmates* (2000) was based upon the concept of a group who interviewed new applicants to the flat. The producer of this show stated: 'We've built a format where we can encourage real life, if you like, to happen more quickly. And it guarantees you get real drama' (Tim Hinks, in Higgins, 2000, quoted in Biressi and Nunn, 2005, p.19).

The debate around reality television continues. The headmaster of Repton School (a fee paying school) Robert Holroyd was reported in June 2009 to have said:

> 'Children's sense of reality is being eroded by

television…Programmes like *Big Brother* and *I'm a Celebrity…get Me Out of Here!* Lead young people to lose awareness of the challenges facing them…An increasing number of young people think that celebrity status is available to everyone, usually through television…They need to understand that "reality television" often shows a modified and highly influenced form of reality.' (Paton, 2009)

Holroyd drew a distinction between the docu-games and the talent shows where he said there was some hard work gone into the performances. How far do you agree with him?

Faking It – How Far is Reality Really Real?

Connected to the debate on realism is the question of how far the participants and producers are consciously manipulating and therefore faking reality. Television companies have often been involved in 'faking', all be it legitimately as in reconstructions and illegitimately as in setting up scenes to support an argument. Two examples of the latter are of a documentary on drugs with the staged filming of a 'mule' (a person carrying drugs) which they broadcast as actually happening and the talk show programme *Vanessa* where the host interviewed a couple about their relationship which was subsequently discovered to be completely false. The couple were actors.

There was even a reality show called *Faking It* (C4, 2000–5) where contestants were groomed to take on (or fake) a different role in society. This show challenged social and other pre-conceptions and showed how we are very much victims of chance in our life opportunities. However there is a different type of faking when deception is used for less salubrious purposes. Chantelle Houghton an unknown wannabe 'celebrity' was put into the *Celebrity Big Brother* house and won the show beating the presenter Michael Barrymore in the final vote. The show's producers had told her to pretend she was a member of a fictional all-girl band called Kandyfloss who had got into the top 40. Chantelle not only won the prize money but also after the show got contracts to model and record.

A celebrated case of deception was set up by a producer who got would-be contestants to audition for a reality show with the bait of £100,000 prize. The catch was that they had to compete to raise £1 million (which would have paid for the show's production costs) but without food, shelter or money. The contestants rebelled as several of them had wanted to use the show to get into the media rather than actually work to

Debates

raise the money to make the show! A production company capitalised on this to make a documentary using archive footage and produced *The Great Reality TV Swindle* (Channel 4, Dec. 2002).

It is not only the participants who are involved with this issue. Factual shows like Reality TV have to face the question of the trust of their audiences. What are the moral and ethical issues about manipulation to make good entertainment? The audiences' contract of trust with the media has certainly changed with the use of digitally manipulated imagery. 'The camera never lies' was a well known aphorism. Photojournalism relied on the belief of 'truthfulness'. In fact images have always been manipulated for example by cropping people, such as disgraced politicians, out of a frame and touching up images of glamorous stars. However digital editing has definitively changed the ability to alter images. There have been countless occasions when photographs have been manipulated to make a better story or a different meaning and audiences realise that manipulation such as airbrushing and cloning are frequently used if not acknowledged. Does this make the reality television show therefore more real because we know other images are digitally altered?

Exploitation – Participants/Audiences

'Conor Digman, the editor of *Broadcast* said, "Reality TV at its best is people struggling to cope with the environment they have been put in. If it's all sweetness and light then it does not make gripping television."' (Burrell, 2003)

So do producers exploit participants through for instance their aspirations in unacceptable ways to make 'gripping television'?

The psychological and social harm that possibly can be caused by using real people has been shown on many fly-on-the-wall style documentaries. The mother in *Sylvania Walters* (1993) complained that she had been misrepresented as a bad mother, a headmaster of a school felt the pressure of being (mis)represented and resigned. Contestants have felt rejected in docu-games when they have been isolated from the group and have found it hard to psychologically overcome this feeling of rejection. Those who are different, whether culturally or in other ways, will not necessarily fare well in the reality show. Susan Boyle was a recent example of this. Here was a middle-aged, rather unattractive and naïve person who had a great voice and certainly pushed the ratings of the show up for the producers, but at some personal cost. It's been suggested that in America 'at least 11 participants on real-life TV shows have recently committed suicide' (Adams, 2009).

The rights of individuals, which they have voluntarily signed away, are not usually in the forefront of a producer or editor's mind as they put together a programme. (The film *The Truman Show* is based upon this idea although Truman is not a voluntary participant.) This is particularly so in the current free-market situation where often cash-strapped small production companies do not have time to ponder such niceties as a particular juxtaposition of images.

Questions over the exploitation of vulnerable people has led to a review of the legislation to protect child performers. The particular concern is Reality TV shows such as Channel 4's *Boys and Girls Alone*, in which children were left unsupervised in isolated cottages in Cornwall; and *Wife Swap*, in which mothers take on wife/mother responsibilities for another family. Ed Balls, the government's Children's Secretary, stated that this was to deal with 'the grey area between factual programming and entertainment.' (Paton, *The Daily Telegraph*, 15 December 2009)

How much editorial control is given to the participants will depend upon how far the

NOTES:

producers feel that showing a particular scene would be harmful to their ratings and so media working practices and values might well over-ride ethical ones. During the exposure of city worker Nick Bateman the person who 'cheated' on *Big Brother* the camera zoomed in for close-ups of him in tears during his humiliation. His confrontation by working-class Craig also signified a social divide. The middle-class, private boarding school education and the amoral working environment of the City led to someone who could cheat on 'friends'; versus the salt-of-the-earth working-class man who rose above all economic disadvantage to be the hero. It is the stuff of dreams (and films) and of course played to stereotypes.

On the other hand are celebrities there to be exploited for audiences?

In *I'm a Celebrity … Get Me Out of Here*, 2003 the actress Daniella Westbrook left the show after eight days in the Australian jungle. The programme-makers were accused of deliberately choosing brittle personalities in the hopes of boosting the ratings. The British Psychological Society set up a working party to establish guidelines in response to this accusation. Even if all publicity is good publicity celebrities often have a persona that they have taken years to build, and away from the support systems of studios, make-up artists, personal assistants this persona can rapidly disintegrate:

> 'media commentators said the reality genre was most successful when contestants were breaking down on camera and the producers of such shows were unlikely to make too many concessions to contestants' (Burrell, 2003). In America this is called the 'Truman show syndrome' (Adams, 2009).

Dumbing Down – Popular Culture

Are genres such as Reality TV dumbing down the content of television and exploiting the baser instincts of society, the Lowest Common Denominator? In so doing is the role of the 'public sphere' of television diminished and the audience side-lined in the democratic process? Or has it allowed a new democracy?

Popular culture is often opposed to a concept of 'high culture'. In factual programming the documentary is seen to be the bastion of quality, of the detached and politically aware commentator, that is high culture, and the reality show as a slide down to mediocrity and superficiality, low or popular culture:

> 'We, the public have to re-assess our attitude to what is and isn't acceptable on TV and vote with our remote controls…Only by eliminating anti-social

behaviour from every aspect of our culture will we finally drag TV out of its continuing slide into the gutter.' (Catherine Hughes' letter to the *Mail on Sunday*, 21 January 2007)

This process is said to be observed in the lowering of standards in factual/documentary programmes with the dominance of format television. In the early *Big Brother* shows in the UK to underline their documentary credentials there were two psychologists who discussed the activities of the participants and whose presence emphasised the pseudo-social experiment of the House. However critics claimed that there were no results to these experiments and no findings which could then help to change or understand society.

The issue links closely with the perceived celebritisation of popular culture where individuals are given status for their popular appeal rather than talent or expertise. Programmes are increasingly made for their entertainment value rather than their educational or information content. Even the news seems to need to be visually stimulating rather than informative; and documentaries and current affairs programmes such as *Panorama* are constantly under threat because they attract only a small audience. The debate has been sharpened as a result of the recent difficulties of commercial television. Should television serve minority audiences or should the majority taste prevail? Who sets the standard?

The 'sobriety' (Nichols, 1991: 3) of the documentary is seen to have been bastardised by the hybridisation of forms that make up Reality TV with its focus on the individual, narcissistic element of the human interest story and personal rather than public responsibility. The focus on the everyday, the emotional, the confessional style, and the apparent superficiality and mundane nature of the topics are central to these debates. This has also been called the feminisation of the media with its interest in relationships, as in soap operas. Another accusation is that it focuses on issues of youth rather than of adult interest. These two combined indicate to some a dumbing down, a banality called the tabloidisation of the media or 'car crash TV'. Broadcaster Chris Dunkley described it as being similar to bear-baiting, the stocks and public hanging (2002).

On the other hand Peter Balzagette (previously of Endemol owners of the *Big Brother* franchise) sees in the new formats a sea change in broadcasting where formats will be influenced by real people, the audience. The identification felt by audiences and pleasures in watching are evident in the numbers who phone in to vote as well as to

Debates

watch. Over the first two *Big Brother UK* series 34 million votes were cast (Biressi and Nunn, 2005: 12). Certainly event television involves people far more directly than other genres and gives them direct access to its construction. *Strictly Come Dancing* (BBC1, 2008) was a classic example of people power. The worst celebrity dancer John Sergeant was consistently kept in the programme by the viewers' votes whilst better dancers had to leave, much to the annoyance of the professionals.

John Sergeant and Kristina Rihanoff in *Strictly Come Dancing* in 2008, right

However this 'democracy' comes at a price according to others. Reality television programmes are seen as 'damaging to our cultural values, making us all voyeurs, entranced by the trivial and often unsavoury activities of "ordinary people", elevated by the media to the status of celebrities' (Bashforth et al., 2005: 26).

A classic example of ordinary to celebrity was of course Jade Goody who was a contestant in the 2002, Series 3 *Big Brother*. She was ridiculed for her apparent ignorance and 'common-ness' but she managed to exploit this in the media and her fame led to an appearance in the *Celebrity Big Brother* house in 2007. The notoriety that she received after being accused of racist bullying led to her appearance on the Indian version where she revealed she was suffering from cervical cancer. From her first appearance in 2002 her life and ultimate death were led in the spotlight of publicity.

What do you think about this? Was this an invasion of privacy; exploitation of celebrity; or publicising the need for cancer screening to young women? Go to www.bbc.co.uk/worldservice/news/2009 (accessed 27/02/09) and *Reality TV Star's Wedding Sparks Death Debate* to hear the 2008 episode, and other clips relevant to this discussion.

Democracy and Reality TV

Does Reality TV help in the democratisation through popular culture by giving access to the powerful voice of the media to ordinary people? Or does the parade of personal lives of celebrities and with it the emphasis on the lives of other elite persons such as politicians undermine democracy?

The combination in reality shows of melodrama, makeover, fly-on-the-wall, personal diary, have brought the personal, moral and social into the public domain. But the political debates and analysis of the situations, such as an understaffed, overcrowded hospital or police having to put huge resources into dealing with Saturday night drunks are not often analysed or discussed. There is no sense, unlike with a documentary, that there is an engagement with the debates on the issues raised.

However for some the access to the media and the use of ordinary people as subjects does represent a democratisation. For them reality TV is a new shared knowledge and experience where the ordinary is the focus. They would see a programme like *Survivor*, where a group is left on an island to survive without the benefits of civilisation as a playing out, at its most basic, of how contemporary society works. In the same way *Big Brother* sets tasks for the inmates to work at as a team and as in society compromises have to be made which can be observed by the audience.

So have the changes in technology which have enabled more individual participation given the audience a more democratic relationship with the

NOTES:

media? Certainly Balzagette (in Biressi and Nunn, 2005: 149) sees these types of programming as giving access to a more diverse representation of the audience shown through the desire to participate via audition or phone votes.

Mandy Rose a producer of the *Video Nation* programmes (BBC2) of the 1990s where cameras were given to ordinary people to record their lives which were then transmitted in a series of short programmes wrote, '... seeing the material that people recorded, I have come to realise that they were articulating something very significant about the gap between television representation and lived experience' (Rose, 2000: 174, in Biressi and Nunn, 2005: 18).

The video diaries had provided opportunities for the confessional style in which people talked directly to the camera (as later in the Big Brother room set aside for this activity) and for these individual stories to highlight other major issues whether the state of the National Health Service or the denial of the Holocaust. Here the personal experience and the public interest were often combined in the 'public sphere'.

The claim that this type of programme presents the reality of the world of the television audience who can see each other in 'real' situations is important. It is about the drama of living in the world today which is not a controlled studio environment. This changes the relationship between producers and audiences; the latter are no longer being beamed *at* but are participating *in* television. The power of the television camera is that it confers status on the person/institution which holds it.

This new 'power' also creates new groups whose loyalty is to the participants. These fan groups or new 'tribes', in terms of reality TV, are temporary and specific to the community established by the programme. The convergence of the media which allows the media event to happen in real time provides opportunity for this temporary tribe to become a new democracy in voting power and a new social group established through interaction about the programme.

Alternatively the view is that marketers and advertisers are using and targeting these new 'tribes' or audiences. Branding of the shows is important and the spontaneous or democratic choices are in fact pre-orchestrated by choices made of the participants, the filming and so on. The idea that we are surveying the participants but that we are also being surveyed for commercial purposes suggests that there are other hands on the strings. If this is so then it means that norms of behaviour are being manipulated for commercial reasons. We are often called a surveillance society in which, as in George Orwell's *Nineteen Eighty-Four* (1949) novel where 'Big Brother is Watching You' posters appear and a two-way television is installed, we are being watched constantly in public spaces through CCTV and mobile cameras and our private spaces can be observed through webcams. Has Reality TV normalised a surveillance society?

Conclusion

As you can see from this brief survey of debates around Reality TV they are not merely innocuous rather entertaining, light-weight programmes. They are the centre for real debates about the world in which we live and the world which we are creating. Do reality shows tell us how to behave or do they reflect our behaviour? The construction/reflection debate centres on are we being manipulated or is there a new democracy? Is it a reflected reality or a constructed one?

The choice may be yours.

Student Activities

Aim: To identify some of the key debates surrounding the reality genre.

Objectives: To explore debates and different theories.

To understand that effects may be attributed to the media.

To discover if the media influences knowledge, values and beliefs (ideologies).

Activity 19a – Representation and Stereotypes

(see also activities 6a and 15)

↘ Teacher: Prepare a series of clips from reality shows with different participants and ensure understanding of stereotypes before commencing activity.

Watch part of a reality game show and pick out any of the following stereotypes:

Name of Show	
Stereotype	Participant
The intellectual	
The gay	
The lesbian	
The white 'Essex' girl/boy	
The black	
The Asian	
The tart	
The stud	
The loner	
The working-class rough diamond	
The upper-class snob	
The bimbo	
Any others	

Can you point out stereotypes that have been used in other reality shows?

- How is each type signified? Look at their dress codes, non-verbal communication; how others behave to them; their accents/dialects and so on.
- Where else have you seen this stereotype in the media?
- Do you think it is used often? If so in what type?
- What effect does this have on audiences' beliefs about different groups?

Activity 20a – Realism

Which of these comments do you believe? Why?

What would be the counter-argument to each statement?

Realism

↘ Teacher: Provide a brief understanding of different types of realism.

A (brief) Realism Time Line

Nineteenth Century

- Literature: Realism with writers such as Charles Dickens.

- Art: Realistic portrayals in art such as the work of the Pre-Raphaelites.

- Photography: The development of capturing the 'real' world visually but still and silent.

- Film: End of the nineteenth century; moving images, e.g. flick books, actuality films, short newsreels, travelogues.

Twentieth Century

Post-First World War: Reactions against 'bourgeois realism'; new world orders.

- Film: Soviet cinema, e.g. Eisenstein's use of montage.

- Documentaries: 'Creative treatment of actuality' (Grierson).

- Art: e.g. Cubism.

- Literature: stream of consciousness, e.g. James Joyce.

Post-Second World War 2: New technological innovations and changes in society:

- Film: Italian Neo realism and French New Wave; British Free cinema; Jean Rouch – cinema-verité.

- Television – documentary – education and information: inherited from newsreel and information films. Technology helps drama-documentary (influenced by New Wave and social realism), e.g. *Cathy Come Home*, 1966; Fly-on-the-Wall, 1970s – capturing reality of ordinary lives (*The Family*, 1974).

- Film: Direct cinema (e.g. Pennebaker). New Technology – digital leads to video diaries.

Twenty-First Century

- The Internet.

- Interactivity.

- Specialist channels.

- *Big Brother* on the web.

- New democracy – web cameras and blogs.

- Film: CGI and magic realism.

Student Activities

20b – Practical Work

(N.B. 20b and 20c could be divided up between groups.)

Aim: To understand how different technical codes produce different meanings/realities.

Objectives: To apply learning to practical work.

To reflect on process.

↘ Teacher: Depending upon ability/time either prepare the dialogue and the location beforehand or allow students to suggest options. Set up time, equipment, groups.

Either:

In groups, record (either in film or still photography) two people in a two minute conversation:

a. First as if they were in a crime drama.

b. Secondly as if they were in a reality TV docu-soap:

• Script the dialogue which should be the same for each scene.

• Decide on characters/personalities and their roles.

• Consider how the way they behave, props, dress might signify their role.

• How many cameras you will need and what angles or camera movements might be effective.

• If you have access to lights these could be used – even a torch is effective.

• If you are doing still photos lay them out as if they were a storyboard with the dialogue beneath each frame and an indication of any sound track.

• If you are filming and can do a rough edit you might be able to put on sound effects or music as well as dialogue.

Or

Activity 20c – Create (either in moving or still photography) a travel advertisement and the opening of a reality docu-game such as *Survivor*. Both set in the same location.

Choose a location which must be the same for the two products. One will be trying to sell the location for a holiday so should look inviting. The other is trying to show how uncomfortable the participants are going to be in a hostile environment:

• As with Activity 20b remember to think about: camera angles and framing; sound track such as non-diegetic sounds like music and sound effects; lighting and colour; *mise-en-scène*.

Reflect either in a discussion or a report on how you chose techniques to conform to generic realism (verisimilitude).

What were the technical and other differences between the two?

You could have a competition and judge the winner for each category.

20d – Extension Activity:

Discuss: How far does Reality TV represent reality and how far does it have to construct a reality?

Activity 21 – A Window on the World

Aim: To ensure understanding of constructed reality.

Objectives: To see different viewpoints.

To understand there is a dominant way of seeing.

> ↘ Teacher: Prepare a list of titles of reality shows for students to see.

We often believe that what we see with our own eyes must be the truth. Have you ever been involved as a witness to an event? Often several very honest witnesses can see the same event but recall it in very different ways. (Wilkie Collins famously made use of this in his novel *The Moonstone*, one of the first detective stories, with different witnesses recalling different parts of the events.)

Why is this? Partly it is because we are selective of things which interest us. Someone might be interested in clothes, another in cars and each will see more of these elements than others. We might interpret an action like a raised hand differently – 'drowning not waving' is a phrase often used to show how the same action can be interpreted differently.

So we all have different 'realities' depending upon lots of factors; not only interests but also age, gender, social class, experience, race, ethnicity, education and cultural knowledge. We also are positioned to read a text by the media. Let's see if you agree within your group about what is real.

⟵————————————————————————————————⟶

Draw a line horizontally across a sheet of paper

At the left end write 'very realistic' and at the other write 'not at all realistic'.

Now put the listed programmes at a position on the line where you think they fit in terms of realism

(these programmes were all broadcast w/b 03/05/09).

The News; *Big Brother*; *Ready, Steady, Cook*; *Panorama*; *Weakest Link*; *Deal or no Deal*; *The Simpsons*; *Hollyoaks*; *EastEnders*; *Trisha Goddard*; *Home and Away*; *Real Rescues*; *Bob The Builder*; *The Real Swiss Family Robinson*; *Ashes to Ashes*; *ER*; *Britain's Best Drives*; *GMTV*; *International Terrorism since 1945*; *Wife Swap*; *Gok's Fashion Fix*; *Top Gear*; *Planet Earth*.

(If you do not know the programme, ask someone to give you a brief outline.)

Compile a group/class profile of realism. Discuss your results. Were there any major differences or did you all generally agree? What does this tell us about our views of the realism of particular genres?

Student Activities

Activity 22 – Accuracy

Aim: To consider the ethics of accuracy.

Objectives: To understand that audiences can be manipulated.

To see that mediation can lead to inaccuracies.

To understand that producers are under pressure to produce entertainment.

�’ Teacher: Photocopy a chart for each student.

Activity 22a – How important is accuracy and truthfulness for:

	Very important	Fairly important	Unimportant	Don't know
A docu-soap				
A docu-game				
The news				
A fly-on-the-wall documentary				
A makeover show				
A travel show				
A crime reconstruction				
A drama-documentary				
A drama				
An historical reconstruction of an event				

Activity 22b

- ↘ Teacher: Prepare an extract from a current docu-soap.
- Watch an extract from a reality show such as a docu-soap. How far do you believe this is an accurate representation of reality?

Is it all accurate? Is it mostly accurate? Is it sometimes accurate? Is it inaccurate? Don't know?

- Explain your answer even if you answered don't know. Why don't you know? What are the problems you have identified?

Case Studies

Chapter 8 Case Studies

After studying these case studies you should be able to:

- Identify key examples of different types of reality show.

- Identify differences between docu-soap, extreme survival, docu-game, talent competition and makeover.

- Apply various key concept approaches, such as narrative, institutions, audiences, representation and media language to each and be able to use a 'celebrity' as a case study approach.

⇒ Activities 23-24

Docu-soap *The Cruise* **(1997), BBC website**

The Cruise was one of the earliest docu-soaps and was based upon a cruise ship touring in various locations. The structure was of parallel narratives as with a soap following the various jobs on board. The action moved around between the different 'characters' doing jobs such as stewards, chefs, entertainers. The editing allowed the development of each mini-narrative and as with a soap, personalities in each appeared. Each group provided a 'type' for audiences. The dancers for example were frequently shown in long shot as a group and often accentuated body shots so therefore fitted the stereotype of 'dancers' rather than being seen as individuals. Other participants were treated as comic interludes by the way they were filmed and shots of them were edited together as with the couple who were confined to their cabin with an infectious disease.

As the viewer got to know each character they were drawn into their lives and developed an interest (identification) with their work, loves, personal triumphs and disappointments. As with life there were no real endings but each narrative was edited to provide a cliff-hanger for the next 'episode'. To encourage this link the show also had trailers to the next episode. The main star of this docu-soap became Jane McDonald, the boat's singer. She was highlighted in the opening sequence where faces were seen through 'port-holes' so the decision of the producers to focus upon her was an obviously deliberate one. Her persona was carefully constructed through various technical codes, such as pose, dress colour, location and camera angle.

The performers on the boat were 'putting on a show' and in a sense this docu-soap also became a classic musical genre where the show must go on whatever happens, and triumph comes from backstage trials, conflicts and tribulations. The sequences of the entertainers putting on their show also allowed the producers to provide the equivalent of *Sunday Night at the London Palladium* entertainment but disguised as a factual programme and at a much cheaper cost.

Jane McDonald's real life profile was raised considerably, and her singing career took off. However she also had to survive the media taunts of lack of talent, manipulation, ambition. Following her success on this programme the preparation and ceremony of her wedding were also filmed as a docu-soap. Her celebrity profile has since been maintained and she is touring, releasing albums and has appeared on *Loose Women* (ITV1). As an article in Thomson Airways in-flight magazine stated: 'She's the sequin-clad queen of cruising who came bursting into our living rooms when she starred in BB1's The Cruise…Britain's best loved docu-soap diva' (*Imagine* (4), 2009: 16–17).

The Cruise showed the other side of the glamorous world of holiday cruises. It showed the work and problems in keeping the cruise running smoothly for the holiday makers. Any serious issues raised, such as how the institutions involved treated their workers, the difficulties in such a confined work/home environment was

NOTES:

diverted by the entertainment and the characters.

There have been numerous other shows in a similar format such as *Airline* (ITV) which follows the work of employees of Easyjet (repeat showing ITV, 2009). One of the advantages of studying an earlier reality show is that there is evidence of how appearing in a docu-soap has influenced the subsequent lives of the participants. Some have not been as lucky as Jane.

The docu-soap format consists of:

- A limited real life context, often a place of work, but can be a village, an island, a department store.

- The context must be sufficiently large enough to have a community of different types from which several personalities appear.

- A 'star' personality who becomes the focus of the show, such as Jane or Maureen in *Driving School*.

- The triumphs and trials of the participants and how they overcome obstacles are followed, for example getting an injured person off the Scilly Isles when a storm is raging.

- Relationships are observed to show how people deal with confrontation or emotions such as grief, disappointment.

- Following individuals creates parallel and overlapping narratives each with their own narrative structure, but with a central theme such as working in a hospital.

- Hooks are used at the end of each mini narrative to keep you waiting to find out what happens next. In one episode of *Airline* the hook was the mysterious content of white boxes being given special escorted delivery which were eventually revealed as boxes of shamrock being taken to an Irish regiment for a St Patrick's Day parade.

- A taster for the next episode is added to hook the viewer.

Docu-game *Big Brother* (Channel 4, 2000–10)

Endemol, a Dutch based company, had first used the format in the Netherlands in 1999 and it was launched in the UK in 2000. It is a high concept programme with high production values and creates an 'event' to be followed avidly by fans over its transmission period (therefore termed 'Event TV', i.e. it has a signified beginning and end rather than an on-going soap narrative). Rather like a World Cup it brings together diverse competitors, eliminates them, and climaxes on a final and an ultimate winner.

The *Big Brother* 9 housemates, left

The story goes that the idea came from watching astronauts in the USA training for space journeys. To monitor their reactions a space ship was constructed with cameras surrounding it so scientists, doctors and others could observe their behaviour 24/7. The astronauts were given certain goals and how they interacted and performed these acts was noted. This was for scientific purposes but it was also fascinating viewing for an outsider and the idea of a show was formed in the mind of the Endemol owner.

There were quite a few technical problems to overcome to make it a possibility for live broadcasting. For instance, the positioning of cameras around the set and the control of editing if the programme was to appear as being in real time needed to be considered. Its original UK producer, Peter Balzagette initially rejected the idea saying: "'The rats-in-a-cage-who'll-do-anything-for-money is something that I doubt we could sell on to commercial television … as currently constituted we feel the show has a narrow market in the UK'" (quoted by Sparks, 2007).

However, since it first began *Big Brother* has been nominated and/or won many television awards such as most innovative show in 2001, in 2002/3, the most popular factual show and in 2004/5/6 the most popular reality show.

Why was it so successful?

1. Economic – Channel 4 and its co-production companies such as Endemol, telephone companies and sponsors like Virgin have benefited considerably from the *Big Brother* franchise in terms of revenue, advertising and ratings. The awareness of the brand is probably one of the highest for a television programme.

2. Formula – Although originating in Holland it was sharpened up for the British market, e.g. evictions weekly instead of fortnightly, and each series adds a new twist to the formula. It is now tried and tested but not yet lacking innovation. However there seem to be signs (2009) that the formula may be weakening with some of the on-line services being withdrawn as uneconomic.

3. Production – It now takes place in spaces linked to a studio space where the 'house' is located (until 2010) and its production costs are

Case Studies

relatively low.

4. Representation – The housemates audition from the audience and their role is to both reflect ordinariness but also difference, to make the mix exciting. The producers try to choose this mix so that it will be volatile (sometimes it becomes too volatile and the police have been involved). So there have been different races, ethnicities, sexual orientations, disabilities represented in the house. However they are all generally young to target the Channel 4 audience. (Look at any group of *Big Brother* housemates to identify the different types represented.)

5. Action – The activity within the set is limited. Activities such as eating become highlights for the inmates. This can generate its own pressures. The Diary room is somewhere that the contestants have privacy away from the other contestants. This is not shown live but edited versions where applicable to events in the house are shown. This confessional has proved popular with audiences. Contestants can choose to play the game or not. Once in the house the producers have little control over how the contestants behave or react. In *Big Brother* 10 the housemates attempted to break out of the compound through a fire exit having been instructed by Big Brother to do something 'entertaining'.

6. Interactivity – The audience feel as though they are involved in the production when they vote. They can also select scenes, re-visit on-line, and in many other ways link into the show. They feel that they are partly constructing the text.

7. Narrative – There is a narrative each week leading to a climax when the eviction takes place. The build up is aided by newspaper and magazine speculation and other television shows. The Big Brother voice-over acts as a narrator, helping to position us and provides a point of view.

8. Intertextuality – The stories of the housemates are often referenced elsewhere. Quite

a few have become minor celebrities and used the show as jumping off points for a media career. The private lives of housemates have been a source of stories for other media, particularly tabloid newspapers. They have even sometimes run campaigns to influence voting.

9. Immediacy – Live coverage when something might just occur which is controversial adds spice to the mundane everyday.

10. Surveillance – Additionally in a society where surveillance is becoming an issue with CCTV cameras, and people being able to delve into our lives through FaceBook and other websites, *Big Brother* raises some key debates.

11. Voyeurism – We can observe how even in a close-knit community where there is competition human beings often behave badly. We as voyeurs watch and gain pleasure from this second hand experience (vicarious pleasure).

12. Mass Audience – Enough of the target audience watch *Big Brother* so that it becomes an event about which you can talk within a group of friends or colleagues; the water cooler/coffee machine chat.

13. Form – It is television designed for the short span attention of a younger television generation who have many other forms of entertainment on which they can spend their time and money.

14. Style – It has a post-modern quality of style of reality with obvious construction such as introducing new contestants mid-way through the game.

Today *Big Brother* is global appearing in many different countries although each show has to be adapted to local conditions. For example in the Middle East the genders were kept strictly apart but it was still criticised for being un-Islamic and was pulled before transmission.

All over the world it has attracted high audiences and its appearance is certainly seen as a landmark

NOTES:

in terms of audience participation, factual television and the new media-scape. Its success has meant that Endemol has been able to 'strike hard bargains with broadcasters wishing to buy it' (Sparks, 2007) in spite of the fact that as a Reality TV show it is quite expensive to make (according to the BBC's Torin Douglas £20 million per year, in Adams, 2009). It has about 200 people…including 50 [cameras] and 13 producers (quoted in Sparks, 2007). *Celebrity Big Brother* has also to pay for (albeit minor) celebrities. However the rewards are enormous. Hill (2005) quotes a 30 second advertising slot during *Big Brother 3* costing £40,000, over three times more than for any other show on Channel 4 in 2003. The same series generated over 10 million text messages and had 10 million viewers for the finale.

In 2000 Channel 4 had taken the unprecedented decision to strip it across the week (i.e. shown every night). This was a gamble as it was scheduled against some heavyweight programmes on the other channels. But the gamble came off and today this is the standard format. It is also supported by other media platforms such as digital channel E4 with four different schedule times, phone texts, videos, books and live streaming on the Internet making it an event you cannot miss. The show is also discussed on other programmes and talked about or referred to by presenters, DJs and so on. It is written about in the tabloids as they monitor it for gossip and possible celebrities. All this prompts conversation amongst the audiences. In the US this is referred to as 'water-cooler TV'. This amplifies the reach of the programme beyond its actual broadcast.

Controversies

There have been many controversial moments in the Big Brother house. In 2004 there was violence when housemates were confronted with two contestants they thought had been ejected. It provoked discussion about manipulation and the decline of Reality TV into confrontation and staged events. The accusation of racism and bullying has also been levelled at the Big Brother House famously with the encounter between Jade Goody and Shilpa Shetty in *Celebrity Big Brother* 2007. Today a Big Brother contestant has 'been interviewed by a psychotherapist and a psychiatrist, and has undergone police screening' (Burrell, 2003). However for audiences the pleasures of viewing are partly to do with the ability to voyeuristically observe these types of anti-social behaviour (violence, racism, cheating) from the safety of their own domestic environment and vicariously watch how these are handled. In fact audience research on the first *Big Brother* showed that 68 percent expressed enjoyment at watching conflict whilst 60 percent

said they enjoyed watching everyday events (Hill, 2001: 36–50, in Biressi and Nunn, 2005: 11).

The *Big Brother* format although based upon observational documentary style (see Wiseman and others in Chapter 2) has some distinct differences. The production is fore-grounded, that is the cameras, events in the house and the competitive element of the game forward the mediated structure. Even the participants are reflective of the structure and use it. Some for example refer to earlier *Big Brother* programmes. Others will comment on how far they are playing up to the camera or how far they are behaving realistically.

The use of the Internet allows surveillance of the housemates at all times by ordinary people. This participation is compounded by the interaction with other sites such as blogs, forums, quizzes, informal voting. All of these allow access to the audience for advertisers.

For the *Big Brother Series* 10 in 2009 would-be participants could post their auditions on YouTube or could go to live auditions around the country (see Channel 4's website). There is a definite eleventh series in the pipeline announced by Channel 4 as its last (August 2009).

Celebrity Big Brother (C4, 2002– with one already planned for 2011) is a popular spin-off of the original combining as it does the popularity of the docu-game with celebrity culture. In *Celebrity Big Brother*, 2006, the unknown Chantelle won the show and became famous (see faking in Chapter 7). The faking of Chantelle as a celebrity and the row over racism in the 2007 show which led to the cancellation of the 2008 show have provided a frisson of the unexpected which appeals to audiences. The 2009 show drew 5.9 million viewers at its peak but declined to just over two million by its penultimate week.

What *Big Brother* and other docu-games showed was that interactivity is a key factor in audience's pleasures.

'Survival' – Extreme Reality Shows

These shows range from forms such as game, historical re-enactments, experiments in human behaviour.

Survivor (CBS, 2000–)
Survivor was one of the first of the extreme docu-game reality shows or 'anthropological experiment'. The first island was near Borneo and here participants had to eat barbequed rats and maggots watched over by the camera. The inhabitants had to vote one person off when summoned by the tribal chief. The 'survivor' after

Case Studies

Survivor contestants, right

13 episodes won a $1million. The show was a ratings success (as estimated by Nielson, the equivalent of BARB in the UK) catering for a voyeuristic audience:

> 'Like the other new reality shows *Survivor* may promise scientific objectivity – we can watch animosities grow and power relationships shift among the islanders, as if we were peering at bacteria through a microscope – but what the series delivers is classic myth: the idea that a seductive Otherness charactizes the East.' (Wren, 2000)

To emphasise this exotic 'otherness' the opening sequence had background chanting and images of flames flickering on naked flesh. In 2002 with *I'm a Celebrity... Get me out of here!*, the format was extended to celebrities as contestants in these types of survival show.

The appeal of these shows where people are left to survive in unfamiliar surroundings such as on an island or in a 1900 house (*The 1900 House*, 1999, Channel 4) seems to provide us with a view of a more authentic world, where people are denuded of the comforts of the modern technological world. But they also erode privacy and perhaps dignity.

The format's controversial aspects were highlighted with a four-part series when a group of children were left alone in isolated cottages in Cornwall entitled *Boys and Girls Alone* (Channel 4, 2009).

This *Lord of the Flies* (William Golding) style reality programme showed the children crying and fighting and led many to feel uncomfortable with its exploitation of children. The concerns about this show led to calls for it to be stopped mid-series (see Debates chapter).

An extreme reality show has a structure which entails:

- Putting a group into an isolated environment for a set period of time.

- The environment is hostile by being without modern comforts or family/friend support.

- The group is observed to see how they survive the experience.

- Various, often unpleasant, tasks are assigned to individuals.

- Individuals are targeted as being representative of different traits, e.g. the bully, the negotiator.

- Human behaviour is observed as a pseudo anthropological experiment.

- Individuals comment on their feelings during their ordeal.

- A voice-over acts as narrator to ensure we can follow the events.

For a case study on *Big Brother* 2 (2001) compared to *Survivor* see Jo Wilcock's *Documentaries: A Teacher's Guide* (2004: 68–77) which shows how *Big Brother* won the ratings war, through the Internet, sponsorship, newspaper and magazine coverage, merchandise and Channel 4's exploitation of the BB brand.

Talent Shows: *Pop Idol* (ITV, 2001)

The talent shows that have emerged use interactivity by having both members of the viewing public in the show and the audience at home voting for the talent winner.

The dynamic between talent and screen presence is at the heart of talent shows. Talent shows and competitions have been around before television whilst the media has used the desire to perform in many ways, such as with game shows. In 2000

NOTES:

ITV produced *Pop Stars* which followed the construction of a band (Hear Say) from auditions to the release of the first record:

'...it showed that vertical integration was the way forward: the emotional involvement built up by witnessing the group's formation would not be squandered, but would neatly segue into showbiz proper. The celebrity capital was transferred from TV ratings into record sales – a transaction lubricated by media coverage.' (Walters, 2002)

This included delaying *News at Ten* so that the band could perform live at the Brit Awards in 2001. There was one element that was not present in this reality talent show and that was interactivity. The band was chosen by professionals not by the viewing audience.

Pop Idol was the key reality talent show to develop from the docu-soaps and docu-games. The show began with auditions which gave way to people appeal as the judges reduced the contestants to the final heats: 'Traditional light-entertainment met cutting-edge formatting' (Walters, 2002). Thus the continuity of genres as well as innovation was present. This resulted in a reality show that had a narrative and emotional involvement and appealed to all the family for the peak viewing period of Saturday night television – 'the Holy Grail'. On the night of the final when Will Young won, the viewing figures were 13 million, four times as many as BBC 1.

Event TV also helped the digital off-shoots of ITV with *Pop Idol Extra* giving record viewing figures for ITV2, just as *Big Brother*'s digital programming had done for E4.

The number of votes for *Pop Idol*, 2002 reached 8.7 million giving £2.5 million to BT and the production companies. This was in addition to the profit from text message updates and 'sponsorship (the show's sponsor, Vizzavi, was part-owned by Vodafone), spin-offs such as live finalists' tour ...and ... a share of the royalties from the record sales' (Walters, 2002). The winners do not make money by winning a prize (which would come out of the production company's profits); their winnings are a chance to become famous and to make more money for the show's creators through record sales.

The production company also makes money from overseas sales and in 2002 the estimated US sale alone for its creator Simon Fuller was £10 million (figures from Walters, 2002).

Following the success of *Pop Idol*, Simon Cowell's company developed *The X Factor* (ITV, Series 6, 2009) a television music talent show. The competition was for aspiring pop singers drawn from public auditions. The 'X Factor' of the title refers to that 'something' that makes for star quality. The actual prize is a recording contract but the other prize is publicity generated, not only for the winner but also for the last few contestants. Simon Cowell judges with others and mentors the contestants. The current show has allowed an audience into the auditorium for the initial auditions.

X-Factor judges (l-r) Simon Cowell, Cheryl Cole, Dannii Minogue and Louis Walsh, left © ITV

The audience for the 2009 final, won by Joe McElderry, peaked at 19.1 million viewers in the five minutes from 9:15 pm when the winner was announced (figures from www.guardian.co.uk/media/2009, accessed 15/12/2009) and it brought in an estimated £75 million for ITV through advertising and the 10 million voter calls and texts at 35p a time. The show has been credited by some with providing the old fashioned effect of bringing together the nation, once the preserve of the BBC's entertainment shows - a 'shameless feel-good tonic for the nation' (according to Midgley, N. *The Daily Telegraph*, 14 December 2009) in times of national economic crisis.

Will Young, winner of *Pop Idol*, far left

The UK version was responsible for the launch of the career of Leona Lewis who has since gone on to achieve worldwide success. Simon Cowell has also gone on to produce *Britain's Got Talent* (ITV) which invites a range of talent not just pop music.

Andrew Lloyd Webber has been instrumental in developing the talent show with lead parts in the West End on offer. Connie Fisher famously won the prize of the part of Maria in *The Sound of Music* in 2006 in *How Do You Solve a Problem Like Maria*. Fisher wanted to be a musical singer but had been unable to break into this world through conventional auditions. She won the competition with the help of the viewers' votes. Connie has had all the adulation that a reality show celebrity enjoys but also the downside of being in the media spotlight with accusations of

Case Studies

not being as good a 'professional' to tabloid stories about her personal life. Her career is still making headlines in the showbiz press.

Talent shows have a formula of:

* Pre-auditioning to select a range of talent/personalities, to ensure there is variety in the finals.

* Interviewing/filming the different personalities in their ordinary life so audiences get to know them.

* Professional jury commenting upon the 'talent' and giving advice.

* Jury is equally shocked and surprised at different acts.

* Jury agree/disagree on talent.

* Television audience helps generate atmosphere with friends/family supporting different acts.

* A series of elimination rounds with two acts being in danger in each episode.

* Audience voting for the final decisions.

* A final with 'hype' generated in the media.

Makeovers/Life-styles – *Mary, Queen of Shops* (BBC, 2007–)

Changing Rooms, 1996 was the first of numerous makeover shows and it was quickly followed by others such as *Ground Force*. The formula is basically, find a house/garden/person/business that is uncared for or failing and bring in a person/team to provide the expertise and energy to transform the object of the makeover in a short period of time. Sometimes they may be one programme as with *Ground Force*, whilst others like *Mary, Queen of Shops* run over a series.

A fashion and retail guru Mary Portas (ex Harvey Nichols) has been looking at individual fashion shops which are failing and helped them turn around. For example, Selkie in York owned by Lucy Weller: as with all makeover shows the

Mary Portas, star of *Mary, Queen of Shops*, far right

person who is being madeover has to face some home truths and make difficult decisions, like getting rid of a favourite dress or employee. As Lucy said,

> 'I had to get over the humiliation of some of the things Mary and her team said. *Part of it is to make a programme and be a bit controversial…*' (my emphasis, Seymour, 2008).

In a development of the format the most recent makeover was of a Save the Children charity shop in Orpington (*Mary, Queen of Charity Shops*, BBC 2, 2009).

In all of these programmes the formula is similar:

* Mary goes in, looks at the weaknesses of the business.

* Talks to camera (us) about these and what she intends to do.

* Has confrontations with owners, workers.

* Almost despairs and talks to camera about this despair.

* Takes the participants to meet some of the top people in the fashion/retail world to get tips.

* Sees the participants changing their attitudes.

* Talks round the recalcitrant employee/owner.

* Opens the store with a champagne flourish.

* Turns the failing business around.

The development on the genre was the charity shop series which followed a similar formula, except many of the people working in the shop

NOTES:

were elderly volunteers who had been there for many years, and for them this was a social rather than a business venture. The stock came from donations some of which were more suited to the rubbish bin. So the narrative (Todorov) was:

- Initial equilibrium – Failing charity shop.

- Agent of change – Mary Portas.

- Disequilibrium – Throwing out the old ways and bringing in new ways of collecting and displaying stock with much grumbling from the volunteers.

- New equilibrium – A shop which was producing a much better income for the charity.

What of course is hidden here was the personal stories of the undermining of the self-worth felt by many of the volunteers who had given much time and effort to support the charity.

The popularity of makeovers, particularly with female audiences, for whom women and teen magazines have run similar articles for decades, can be seen in the number of shows available. Ask yourself what messages does it give to women that they need a 'makeover'?

Celebrity Case Study – Jade Goody, 'I sell newspapers'

Jade Goody was in the 2002 *Big Brother* 3 house where she was the fourth from last to be evicted. At the time she was 21 and a dental nurse with a troubled childhood behind her. The attacks by the tabloid press were marked by her class and gender exemplifying 'the ways in which her rise to celebrity was entrenched within discourses of class. Her apparent intellectual ignorance, voice and overweight body were marked negatively as working class' (Biressi and Nunn, 2005). She appeared on the front pages of the tabloid newspapers over 80 times whilst she was on the show. She was called 'the most annoying woman in Britain' (*The Times*, 23 March 2009: 51, Obituary). As working class, loud, apparently uneducated and over-weight, she was not the ideal for a female celebrity. Quotes of 'stupid' sayings were reported in the press, such as 'East Angular' was abroad and Rio de Janeiro a person. But negative tabloid coverage such as being called 'the pig', 'a monster' and a 'nasty slapper' with calls to 'vote to lob the gob' was countered by positive viewing responses and when she emerged from the house, in an over-tight evening gown, she was able to make a deal for half a million pounds with the tabloids. 'The former editor of *Now* magazine wrote recently, "I wanted sales. I soon realised that every time I put Jade on the cover, I got them"' (ibid.), and when *Heat* magazine put her on the front cover in August

2002 'it enjoyed its biggest sale, of more than 600,000 copies…The magazine's editor Mark Frith later said: "Jade helped to define us. She became synonymous with *Heat*, but was also emblematic of a new era of celebrity"' (ibid.). So Jade not only represented a type of woman, a particular class, but also the persona of reality celebrity.

Jade herself said, 'I did so well because I wasn't playing a game. I was just being Jade' (ibid.). She remained a media celebrity appearing on other reality shows like, *What Jade Did Next* (C4, 2002) and produced an autobiography which was a best seller and launched a successful perfume, amongst other businesses. Jade's celebrity status was based on her spontaneity and on her willingness to share every aspect of her life. Jade personified the breakdown of the division between the public and private that reality television seems to symbolise. It was her openness which seems to have caught the imagination of the public. Whether they scorned or sympathised her personality and her willingness to share all attracted attention. Jade was able to sell her interviews for £10,000 and she later sold her wedding and christenings for over £1 million becoming a multi-millionaire.

Jade summarised herself as a reality celebrity star saying, 'I put myself in the limelight and I like my job…I know it's a circle and they build you up to knock you down, and I'm happy to live with that. I sell newspapers' (ibid.).

She remained in the public eye through tabloid coverage and was again involved with the Big Brother House five years after her first appearance, but this time in the now notorious 2007 *Celebrity Big Brother* where she was accused with two others of racial bullying of Shilpa Shetty, the Bollywood star. However there was a sense in which class was also a part of the antagonism between them with Shilpa being perceived as of a 'better' class with servants in India, than the others. So Jade had taken on a different narrative role, no longer the hero battling against tabloid prejudice but now the villain.

The effect of the 'racial' comments was catastrophic for Jade's career. The press were antagonistic, the perfume was withdrawn and work dried up when she was dropped by her agent. She apologised and was re-building her career with the help of Max Clifford, the publicist when the news of her cervical cancer broke. However for *Big Brother* with its falling viewing figures the 2007 controversy was a shot in the arm as ratings soared, but Channel 4 lost its £3 million sponsorship from the Carphone

Case Studies

Warehouse (*The Mail on Sunday*, 21 January 2007: 19).

Goody remained in the public eye up to her death and beyond. Since her untimely death from cervical cancer the image has of course changed. What does she represent for audiences other than East End and Essex girl? She signifies the possibility of transformation from working-class deprivation to celebrity millionaire and the escape from British class boundaries particularly for the groups traditionally in the lower classes of C2, D, E and F. She also represents an authenticity. She had no real talent and she used her ordinariness to reflect her background. As some observers at her funeral said, '"We loved her because she was like us, a bit of a mess maybe, but real"' (Appleyard, *The Sunday Times*, 5 April 2009).

These brief case studies cover some of the major areas of format television. There are of course many other examples possible. In studying any format though it is important to keep the key concepts of text, audience, producers, industries and the debates in mind to provide a clear methodology for an analysis.

NOTES:

Aim: To bring together knowledge of reality shows to analyse specific examples.

Objectives: To observe intertextual and cross media links.

To get students to use key concepts; to identify sub-genres; to discuss issues raised by these shows.

Activity 23a – Docu-soaps – View *The Truman Show* (dir. Peter Weir, 1998, 99 minutes)

Plot synopsis:

Set in Seahaven, an artificially created town, which is the centre of a continually running television show where all the people present in the town are actors or film crew except for Truman Burbank. He was chosen from five unwanted babies by producer Christof, who has built a gigantic domed studio to enclose Seahaven. The enclosed studio allows the producers, directors and crew to control every aspect of Truman's environment. Actors simulate friendship or relationship to Truman. In order to prevent Truman from trying to escape and discover the truth, his father is 'killed' when Truman is a child in a staged boating accident, making Truman subsequently afraid of water. As Seahaven appears to be an island, this means that Truman will not explore beyond the 'island'. Truman has a stage wife, Meryl, but he has fallen in love with the scene-extra called Sylvia, who was removed from the cast by the producers while trying to explain to Truman the true nature of his life. Various factors begin to make him aware of his situation. In his bid for freedom and to find Sylvia, Truman finally overcomes his fear of water and tries to escape, despite an artificially created hurricane on the 'ocean'. He sails to the end of his world – a studio wall. Christof reveals the truth and tries to persuade Truman to stay, arguing that the artificial world is as truthful or real, as the 'real world'. Truman, decides otherwise and leaves his television audience and steps into the 'real world' to cheers from his viewing audience.

Discussion: What issues does *The Truman Show* raise about reality shows? Here are some questions to help:

1. Why did Christof design Seahaven and Truman's part?

2. The audience of the television show have views about the show, what are they?

3. What are your views about this type of experiment?

4. How does Truman try to exercise some freedom and rights?

5. What do you think about the actors who take on the roles in the show?

6. Would you have viewed *The Truman Show* if this had been for real?

7. Are there any reality shows you feel are like *The Truman Show*?

Student Activities

Activity 24a – Another sub-genre

↘ Teacher: Record and watch one of the following: a docu-game, or a makeover, or a talent show, or a survival show depending on what is available and what will appeal to your students.

• Use the analyses in Chapter 8 and complete an in-depth study of one of these sub-genre categories.

Hint: Use the key concepts as a template to help cover all the main areas: textual analysis – micro; narrative and genre – macro; audiences; producers; institutions; values and beliefs, such as stereotyping; debates about realism; criticisms such as dumbing down.

(This could be done as a class activity or different groups could be given one key concept to research and then present their findings to the class.)

Activity 24b – Apply the key concepts to a reality TV star/celebrity. Do a presentation to the class.

Chapter 9 Conclusion – Intimacy, Immediacy, Interactivity

⇒Activities 25

Inside the box labelled 'Reality TV' is a range of different programmes. These involve the blending and blurring of factual conventions with dramatisation in such styles as fly-on-the-wall documentaries, life-style programmes with makeovers and putting people into unusual situations as social experiments, docusoaps and docugames. In a sense Reality TV is the perfect post-modern text, using the banal and the ordinary, television as self-reflexive, learning something beyond immediate experiences in a hyper-reality and hybridisation.

From its roots in programmes about everyday life and social realism dramas, Reality TV has emerged as a significant television category with which all terrestrial television has at some time flirted if not got into bed with, being comparatively cheap to produce and attracting large audiences.

What is Reality TV's place in the history of television and what is its future?

Ofcom in its 2008 report stated:

> 'The growth in Factual output on the PSB channels in recent years continued in 2007, to 11,162 hours, up from 10,570. Increases in output in the past year were driven by lighter, less serious, Factual sub-genres such as Magazine formats, Leisure & Hobbies and Factual Entertainment.
> (www.Ofcom.org.uk/tv/psb_review, accessed 21/07/09)

This increase in the number of hours given to format television is partly due to the economic constraints of recent years combined with new technology and the fragmentation of audiences. These factors have led to a gradual decline in advertising revenue for commercial channels which are fighting hard to maintain their positions in the media market. Reality programmes have been one of the main genres to benefit. The BBC, although having the buffer of the licence fee, is also not immune to the ways audience behaviour has changed and the access given by new technologies.

There have been many who have criticised the format show, but their resilience is shown in the way that they have morphed and hybridised. Today they are an integral part of our popular culture, so much so that people turned out in their thousands for the funeral of a young girl from Essex whose fame was based upon being an ordinary person on a reality show. Producers

encourage us to believe participants are 'ordinary people' representative of ourselves, but they often choose out-of-the-ordinary people who are highly entertaining and who take on roles within the narrative of the programme, such as hero or villain. They can become stereotyped by the way they are filmed and edited to be representative of a group or type, such as the cad, the chav, the bully. They provide audiences with identification pleasures, voyeurism and vicarious experiences. They are said to feminise culture (often a pejorative label) by focusing on celebrity and gossip. They are factual rather than fiction but these edges are blurred. Their values are closer to entertainment than education with an emphasis on personal stories rather than ideas. They do not have a social commentary and are not meant to enlighten or create social change as are documentaries. Some accuse them of signalling the death of the prestigious documentary, but they cannot be ignored and have gained plaudits in television awards. In 2009 *The X Factor* and *Big Brother* were the winners in the inaugural DS Reality TV awards (www.digitalspy.co.uk/reallitytv/completecoverage/realitytvawards/, accessed 08/04/2009).

The power of this format is seen in the way that celebrities have become involved with shows like *I'm a Celebrity…Get Me Out of Here!* (ITV), *Celebrity Big Brother* (C4) and *Celebrity Wife Swap* (ITV).

It is said that all genres go through stages of development before they fade from popularity. The reality genre seems to be currently (2009) in quite robust health even with the Channel 4 announcement of dropping *Big Brother*, but inevitably it will undergo changes as the media and its audiences evolve and the model for production adapts to the new media-scape. What is the future of the format? As new technologies become available and convergence happens and as television becomes more fragmented in its audience appeal, genres will continue to blend, diverge, hybridise. There may also be a reaction to the 'big brother' concept of surveillance television as the public debate about privacy continues. Perhaps as ordinary people become the stars of their own blogs and webcam stories, format television may become less appealing for mass viewing. But whatever may take over, Reality TV will always be one of the most significant television genres at the turn of the new millennium.

Can we learn something from the popularity of the format? Are ordinary people more interesting to viewers than professionals? Is Reality TV a

Conclusion

reaction against the over produced, digitally enhanced, airbrushed images which we have consumed over the last few decades? How far can the camera invade the everyday and exploit our desire for 15 minutes of fame? Is the barrier between the public and the private totally broken? Or will viewers want to revert to the gods and goddesses of the silver screen and put celebrity back into the domain of a few. For the professionals these questions are important as they try to gauge where the next trend in broadcasting will be. However, even if like the interviewees of the *Andover Advertiser* (see Activity 13) you find reality television shows 'boring', 'cheap', 'lame', 'over the top', load of rubbish' and populated by 'idiots', their all pervading presence on the global media scene means they cannot be ignored and studying them will provide an insight into the way that the media and society is developing in the twenty-first century.

NOTES:

Activity 25

Aim: To practise skills for a controlled test on reality television.

Controlled Test Simulation

➥ Teacher: Either photocopy the BBC guidance for commissioning and DreamIsland's site – see below – or show them to the class before they begin work.

Email:

From: Head of Pieinthesky Independent Production Company

To: All Producers

Subject: New Reality Show

The BBC has been successfully producing reality television since the 1990s. They are now looking for new formats to refresh their present schedules and to compete for a younger audience. I would like you to pitch for a new reality show commission. Remember in times of economic stringency we cannot be seen to spend too much on these shows, so expensive celebrities will not be employed. As we do not wish to limit ourselves to the BBC your idea should also be able to run in commercial television with minor changes. Identify which commercial broadcaster would be interested and why and provide the channel information when you pitch your idea.

Please be ready with proposals by the end of next month.

Regards

Peter X. Pect

Task 1

What do you think are the elements which make a reality show a success? You need to consider at least three different types of show and how and why they have developed over the last two decades. Ensure you give examples from shows before 2002.

Task 2

a. As an independent production company you have been asked to pitch for a new show.

b. Decide which channel you will be pitching to and define your target audience.

c. Look at the BBC guidance and at DreamIsland production company's pitch to prospective participants (see below) and select a commercial company such as ITV/Channel 4 or the BBC.

d. Come up with a new idea for a TV Reality show that would be both popular and inexpensive. Identify its audience and its potential to attract advertising and/or sponsorship if on commercial television. Justify its use on a PSB if on the BBC.

e. Prepare the pitch to give to the commissioning agent. Write a treatment for your new idea; suggest a title; include a summary of the show's action; whether it is a docu-soap or event TV and so on; the target audience; the time of broadcast and how long; the number of shows; the purpose of the show; how it will be new and innovative – its USP; any issues that might arise; how you would find participants, and if it is for commercial television what are the sponsorship and advertising possibilities.

Student Activities

Helpful Hints remember:

- Large sums of prize money would eat up profits or the BBC's licence fee.
- Shooting on location is cheaper than a studio set which employs electricians, carpenters, set designers, lighting, etc.
- Using natural light and low-tech digital is less expensive than having a large technical crew.
- Exotic locations are expensive.
- Using real people means no costumes, make-up, etc.
- Interviewing the public is free, employing actors costs.
- Researchers have to be paid – so the more research the costlier the programme.
- Camera crews following one group for a year would be expensive.
- Post-broadcast costs like psychologists to help participants, help lines about issues such as bereavement, or lawyers to defend accusations from participants would add on-going costs.
- The BBC is a public service broadcaster.
- Issues of representation and bias must be addressed.
- Accuracy and truthfulness are important (see regulators the BBC Trust and Ofcom).
- Audiences need to know what the sub-genre is so some codes and conventions must stay but they will be attracted by innovation in developing the genre.

Task 3

Using the idea you have pitched in task 2:

either

Storyboard the opening sequence (about 20 frames) to show the commissioners.

Remember to include sound track and graphics like logos and titles.

or

Prepare a web page for your production company to encourage participants to apply for the show.

Task 4

either

Imagine the show is about to be broadcast, write a positive review of the show for a listings magazine saying why it will be successful and how it will appeal to its target audience.

or

MediaWatchUK (www.mediawatchuk.org) is an organisation that campaigns to ensure the media does not go beyond boundaries of decency and privacy. Imagine you are writing a letter on behalf of the production company to MediaWatchUK to answer their concerns raised about reality television.

Here is information to help with your research for these tasks:

From DreamIsland Website

www.DreamislandTVProduction.com/content/become-a-contestant/htm

'Here at DreamIsland TV we have a different approach and if you are short listed you will enjoy an exclusive couple of days at a secret venue while we assess your suitability for the show. From the very start of the process you will be treated like a star so get ready to be a real celebrity.'

It will be a vote from the viewing public on both TV and on-line to decide who stays on the island and who gets rescued. So every participant has the opportunity to post messages to attract votes from the public.

There are a number of special prizes for those contestants who perform a task well or entertain the other guests in a unique way. The Island Chieftain will set fun challenges in order to enable you to earn extra privileges

From the BBC commissioning website

www.co.uk/commissioning/tv/network/genres/factual_features

BBC ONE

Pre-watershed Features and Factual Formats on BBC One

Shape

Likely to be 30 minute returnable formats built to run and run, and upbeat 60 minutes singles.

Requirement

Programmes that work best in this area plug into the national mindset and then find positive answers to questions that affect us all in our everyday lives. They should be modern and dynamic, driven by passionate talent, which can include new faces.

Crucially, these programmes should be able to bring the household together in the early evening, offering different types of people different reasons to watch the show. *Rogue Restaurants* provides hard-hitting consumer empowerment, but it's also an entertainment proposition, with humour and great chemistry between two passionate presenters.

They also need short, punchy titles to grab the attention on the EPG.

BBC TWO

The range of different Features and Formats on BBC TWO plays a very important role in bringing younger audiences to the channel. Features and Formats on TWO should break new ground and change our perspective on the world.

Whether it's bringing different perspectives to established subjects – as *Chinese Food Made Easy* has for food – or showing how unlikely subjects or areas are relevant for modern life, as *Tribal Wives* does with anthropology.

Mid Week Features and Formats on BBC Two
Shape

We are hungry for fresh formats to play at 2000, though they need to be strong and content rich enough to work at 2100 too. Preferably 60 minutes, but 30s are not out of the question.

Requirement

Formats should have a clear streak of originality, led by faces who are expert, energetic and opinionated – almost a maverick in their area, and prepared to throw themselves into things, like the *Hairy Bikers*. However, they don't have to be established faces – in fact, new faces and talent are actively sought.

We're looking for different topics to add to our successful stable of food and gardening programmes. They should have a different way of looking at the world and crucially, have real world relevance and impact.

Student Activities

Think about fresh formats like *Mary, Queen of Shops* that work on a subject-based level and a human story level – so we find out about a new subject (or a fresh approach to a familiar subject) but also learn a little about human nature; bravery and delusion, success and failure.

BBC THREE

Prime time formats on BBC Three

Shape

The shape will depend on the idea – *Kill It Cook It Eat It*, *Young Mums' Mansion*, *Britain's Missing Top Model* are all successful landmarks and all different shapes.

Requirement

We're looking for landmark formats that are arresting and audacious, but always linked to an urgent question for the younger audience.

Be ambitious about impact, and unafraid to ask difficult questions in setting up the idea. However, the format needs to flow from the original premise, with format points clearly used to augment stories and characters, not as manipulation or contrivance.

Shape

We're keen to explore new shapes and ideas for this competitive slot.

Requirement

One of the main ambitions on the channel is to reinvigorate pre-watershed content, so shape and form are not set in tone.

Successful formats at this time, like *Don't Tell the Bride*, are quirky and with a sense of fun or mischief, but also warm and inclusive for a broad young audience.

Think about talent who can encapsulate this tone (as George Lamb has on *Make My Body Younger*), and formats that can vary from the street-smart to the glamorous.

Chapter 10 Teaching Schedule

Week 1 – Introduction: What is reality television (Chapter 1; Activity 1)

Lesson Aim: To create a definition of Reality TV that includes all the different sub-genres which can be included in 'reality television'.

Lesson Objectives: To enthuse students and tap into their knowledge.

To set out parameters of what is involved and brainstorm ideas.

To understand how genre is a term which is not only about typicalities, codes and conventions but also about values.

Materials: Clips from a range of reality shows.

Week 2 – Where does Reality TV come from? (Chapter 2; Activities 2a, 2b, 3a, 3b)

Lesson Aim: To understand the historical context of Reality TV and the issues it will raise.

Lesson Objectives: To follow the development of the documentary into format/reality television.

To establish how different elements, technology, economics, etc. combined make Reality TV possible.

To show extracts from documentaries to illustrate how factual television has changed over time.

To understand the issues that will be raised such as truthfulness, accuracy, bias, representations.

Materials: Clips of different types of documentaries from different eras.

Week 3 – Genre (Chapter 3; Activities 4a, 4b, 4c, 5a, 5b, 5c, 5d, 6a, 6b)

Lesson Aim: To understand the different reality shows and different target audiences.

Lesson Objectives: To identify different sub-genres and codes and conventions.

To understand there are different audiences for different types of show.

Groups to research a sub-genre and shows ready for a presentation.

Materials: Clips of sub-genres; sheets of paper.

Week 4 – Textual Analysis (Chapter 4; Activities7a, 7b, 8)

Lesson Aim: To provide the toolkit necessary for doing textual analysis of a reality show.

Lesson Objectives: To show how a reality television show is built up of separate elements.

To analyse the different elements used in various sub-genres and their effects.

Materials: Opening sequences; lists of technical codes; logos.

Week 5 – Watch a Whole Show (Chapter 4; Activities 9a, 9b)

Lesson Aim: To show how narrative is constructed.

Lesson Objectives: To analyse a particular show into its components.

To use different narrative theories.

Materials: Prepare narrative analysis sheets depending upon theory and type of show used.

Week 5 – Audiences (Chapter 5; Activities10, 11a, 11b, 11c, 12, 13, 14a, 14b, 14c, 14d, 15, 16)

Lesson Aim: To understand how audiences are active and varied.

Lesson Objectives: To target different audiences by researching channel commissioning.

To use own experiences and research other audiences.

To see that audiences use reality shows for different purposes (gratify needs).

To investigate if there are effects on audiences of watching reality shows.

Materials: Activities set out for Chapter 5.

The aim here is to provide a teaching schedule which can be adapted to suit timetable and student needs. The division into 'weeks' is nominal and depending upon the number of lesson slots available the plan could cover up to one term. Each 'week' is linked with a chapter and the activity sheets. The order is not prescriptive and can be changed to suit individual circumstances.

Teaching Schedule

Week 6 – Industries and Institutions (Chapter 6; Activities 17a, 17b, 17c, 17d, 17e, 17f, 18)

Lesson Aim: To understand how and why the television industry uses reality shows.

Lesson Objectives: To show that there are different stages in production from planning to broadcasting.

To research the different ways in which shows are marketed.

To discover the ways reality shows deliver secondary audiences and extra revenue to production companies.

To investigate how different channels use reality shows in their schedules.

To look at the issues of financing and regulating television in the new digital world

Materials: Television schedules.

Week 7 and 8 – Practical Application of Learning (Activities 6b, 20b, 20c)

Lesson Aim: To put students' understanding of reality shows into a piece of practical work.

Lesson Objectives: Prepare a planning script.

Put a production schedule together.

Produce a short storyboard or an extract.

Evaluate how far it meets the criteria for its sub-genre.

Materials: Camcorders/editing; digital stills cameras/computers; paper; pencils; glue; scissors, etc.

Week 9 – Debates *The Truman Show* Activities (Chapter 7; Activities 19, 20a, 20b,20c, 20d, 21a, 21b, 22a, 22b, 22c, 22d, 23a, 23b)

Lesson Aim: To understand critical debates surrounding Reality Television.

Lesson Objectives: To identify a range of issues that reality shows raise such as Representation; Realism; Faking; Accuracy; Power of the media.

To ensure students are aware of these using activities from Chapter 10.

To discuss the political, psychological, moral and social issues involved with reality television.

Material: DVD of *The Truman Show*.

Week 10 – Consolidation (Case Studies Chapter 8; Activities 24a, 24b)

Lesson Aim: To consolidate knowledge.

Lesson Objectives: To review the key concepts.

To summarise the main points to remember.

To test whether students understand the key concepts of genre, narrative, representation, realism, industries, audiences.

To apply them to specific genre case studies and a celebrity case study.

Materials: Create a quiz aimed at own student level. Prepare a list of words from the glossary that they should try to use in their work as well as learn and revise.

Week 11 – Mock Controlled Test (Activity 25)

Lesson Aim: To prepare students for controlled test.

Lesson Objectives: To look at previous questions and mark-schemes (see for example AQA website).

To practise skills and apply knowledge under timed conditions.

To provide feedback for students' work to improve for test.

To point out where wasted time or missed the point or failed to provide evidence of what they know.

Materials: Paper, pens, coloured pencils, rulers, rubbers; copies of Activity 25, previous tests.

NOTES:

Glossary

Accessed Voices – used in documentary to provide evidence from ordinary people rather than professionals.

Actualité/y – the early very short films were often of actual events happening around the film-makers as they experimented with the new medium – so actuality became the term used for them.

Anchorage – words can anchor free floating images into a specific meaning. First used in this way by Roland Barthes.

Avid (see fan) – an avid is a fan who is completely submerged in the subject, whether it is a programme or a star and that is the complete focus of their attention.

BARB – Broadcasters Audience Research Board; this organisation provides independent audience ratings and statistics for broadcasters.

British Documentary Movement – led by John Grierson and at its height in the 1930s and 40s it is seen as one of the most important influences on British television and film both in content and style.

Cinéma-vérité – truthful cinema. The idea of the French film-makers was to apparently capture events as they happened rather than construct them.

Close-up – the camera comes very near to the subject so that details such as expressions can be seen and the audience identify with the subject.

Continuity Editing – (sometimes called motivational editing) editing where the themes, ideas, narrative are linked through specific cuts to lead the audience into following the logic from one frame to another, even if there are ellipses.

Connotation – used in semiotic analysis to show how signs can suggest more than their surface meaning so a red rose can connote romance (see denotation).

Convergence – merging of forms of delivery: the Internet, television, cable, satellite, phones, computer-based media combine.

Cultivation Theory – this theory suggests that as consumers of media culture we are taught or imbue a particular way of seeing and the messages that the media convey.

Cultural Imperialism – the way that one culture can dominate many others because of the control it has over the medium. One classic example is the Hollywood style of film-making because of the dominance of Hollywood studios.

Denotation – the surface meaning of a sign or combination of signs – so a red rose is a flower coloured red (see connotations).

Diegetic – the diegesis is the world of the narrative. Even events not seen or heard directly are part of this world. Non-diegetic elements are not part of the narrative world such as theme music on a soundtrack.

Direct address – used when the audience is directly addressed, for example when someone talks direct to the camera – see indirect address.

Direct cinema – this is a form of film where there is no obvious intervention by directors in the material.

Documentary – 'the creative treatment of actuality', John Grierson's definition for factual documents. There are many styles of documentary such as observational, expository, poetic, authored and so on.

Docu-game – the combination of a game show but following the participants in real time as they compete for a prize.

Docu-soap – following characters living out their real life using the soap format of parallel and interlinked narratives with 'heroes' in each narrative.

Drama-documentary – the combination of codes from the two types; so that what is a fictional story is made to look like fact, or what is a factual reconstruction is dramatised with fictional elements. Often with political or social intent.

Editing – There are different style of editing for cause and effect or for emotional purposes: motivational and montage editing. Cutting images/sound together to create a juxtaposition for meaning.

Effects – media effects is usually the term given to the debates about how far the media influence behaviour such as with copy-cat actions or beliefs about stereotypes.

Ethnography – the study of people in small groups. Studying their way of life in-depth – a form of qualitative research.

Fan (see avid) – a person who will keep up with all the current news, information, gossip and so on and will invest time, energy and money into their fandom (comes from 'fanatic').

Fly-on-the-Wall – Used to refer to documentaries starting in the 1970s from direct cinema where the camera observed (like a fly-on-the-wall) every action of a particular group as it happened, apparently unedited or directed. At broadcast time it had to be edited to fit a broadcast schedule.

Format TV – artificial construction of events set in real locations and situations often with the general public as its 'stars'. It has a beginning, middle and end to the event.

Free Cinema – used to refer to the 1950s group of documentary makers in the UK who observed working-class life such as an East End youth club or workers at the market in Covent Garden. Many of the people involved went on to work in the British cinema of the 1960s and 70s and introduced a new social realism.

French New Wave – a style in post-Second World War France where young directors wanted to catch the moment and be more natural than the usual studio based films had been. They would put hidden cameras on the street to film actors in 'real' situations as the everyday activity carried on around them.

Genre – codes and conventions identify a genre, a type of story. These are constantly changing as a process. Hybrids and mixing of genres create new ones.

Hegemony – linked to Antonio Gramsci's work in the 1930s derived from Marxist theories. Refers to how different groups can be persuaded to follow the dominant ideological position or political reasoning which may not be in their best interests.

Hybrid – a hybrid genre is one which mixes more than one type of text. Sometimes this is called mixed genres or 'inbreeding' (Staiger). Documentaries which use the soap conventions of parallel narratives, on-going stories are an example. Today there are other hybrids such as docu-game shows, makeovers and talk shows. These usually have much higher ratings than a traditional documentary.

Hyperreality – Jean Baudrillard's influential idea on popular culture – humans can no longer tell what is real because they are in a world of signs created by the mass media and presented as 'real'. So for example the Iraq War was a videogame played out through the mass media where the real and imaginary were combined.

Glossary

Hypodermic model – see Effects. This is a simple model that says if you experience something in the media it will influence you directly. It suggests audiences are passive receivers rather than active readers.

Ideologies – beliefs, therefore not factual truths about society, such as attitudes about certain groups, or the values put on certain cultural activities. Stereotyping can produce ideologies about class, race, gender and so on.

Indirect address – is addressing the audience through events, dialogue, etc. inside the diegesis not directly at the audience.

Intertextual – references made to other texts which help to create meaning by linking ideas.

Italian neo-realism – Like the French New Wave appeared after the Second World War and was trying to represent the real life of people through its unstructured style.

Juxtaposition – putting two elements together (pictures, sounds, etc) to create meaning either by continuity or by clashing.

Mediated – all texts are mediated, i.e. they do not come directly to us but travel through a medium such as television which influences their production and meanings.

Metonymy – objects, etc. in a text which stand for some idea. Frequently used in adverts, e.g. a crown stands for royalty.

Mise-en-scène – the objects and composition within a frame, including lighting, camera, colour, positions, framing.

Modality – the expectations of believability and realism of a text. A high modality seems closer to reality.

Montage editing – putting together or juxtaposition of short edit cuts in a random way to create a political or emotional effect.

Observational Documentary – where the documentary maker observes the action without commenting on it, allowing the audience to create their own understanding.

Moral Panic – the media create panics about groups or issues such as immigration which generate reaction by authorities (S. Cohen).

Motivational Editing – similar to continuity editing. It relies upon cause and effect, i.e. actions, etc. are seen to be motivated by the way they are juxtaposed.

Polysemic – meanings in texts are open not closed, they have many (poly) meanings and audiences can choose to read them differently.

Product placement – a branded product is used or placed in a programme so that the brand can be seen by the viewers. It is a form of indirect advertising. Not yet allowed officially in the UK by Ofcom, but it happens regularly, e.g. with a car being used by the hero of a detective series.

Public Access – programmes which allowed ordinary viewers to become broadcasters, such as giving feedback on television shows or making their own brief documentaries.

Qualitative/quantitative research – two different types of research: qualitative will look in depth at a small number of factors; quantitative research will look at the larger numbers such as the number of violent events seen by children on television over one year.

Realism/reality – ways of conveying a sense of the real through camera style, narrative structures, sounds, editing, dialogue, characterisation. There are different types of realism: naturalism; classic narrative; social realism; sur-realism.

Representation – ways of presenting groups which make the individual in television programmes stand for the group. So the Institution of the police can be represented by a particular person. Can lead to stereotyping where a short-hand of signifiers are used e.g. wearing glasses equals intelligence or 'the geek'.

Scheduling – the organisation of the sequence of programmes in broadcasting to target audiences.

Set-ups – when a production team have set up the shot in advance – for example positioned the camera and interviewee.

Stripping – scheduling a programme across the week on every night at the same time, e.g. Big Brother on C4 at 9 pm.

Tentpole shows – shows which hold audience ratings up at their highest level so supporting surrounding programmes.

Tribe – a group who become linked by their fandom at a particular short-lived moment.

Two shot – when two people are in the frame, such as in a conversation.

Two-Step Model – a refinement on the hypodermic model in that it sees audiences being influenced through stages with influential groups helping to develop the message.

Vicarious – second hand experiences. Often used when discussing why audiences watch shows. They can see events and incidents and explore their own reactions and emotions without actually experiencing them for real.

Voice-of-God – this is a commentary spoken by an off-frame narrator. It gives information in an authoritative manner; or it guides the viewer's point of view. It suggests some form of objectivity.

Voyeurism/voyeuristic – the way that audiences will look at objects and people or events to gain a certain pleasure (even if ghoulish or sexual). The object of the gaze is unable to resist this look as the voyeur has the power to enjoy it.

Watershed – an agreement between broadcasters and regulators that material unsuitable for children and family viewing will not be shown before 9 pm. Sky have decided to use 8 pm as their watershed.

Bibliography

Adams, G. 'Lessons from America on the Dangers of Reality Television', *The Independent*, 06/07/09, www.independent.co.uk/news/world/americas/essay, accessed 18/08/09

Appleyard, B. 'Jade, Queen of the East, is Given a Royal Farewell', *The Sunday Times*, 5 April 2009

Armstrong, R. *Understanding Realism*, London, BFI, 2005

Barnouw, E. *Documentary: A History of the Non-Fiction Film*, New York, OUP, revised edition, 1983

Bashforth, Chaplin, Law, Molony *Understanding Media*, DA204 Study Guide 1, Milton Keynes, Open University, 2005

Bignell, J. *An Introduction to Television Studies*, London, Routledge, 2004

Bignell, J. *Big Brother. Reality TV in the Twenty-first Century*, Basingstoke, Palgrave Macmillan, 2005

Biressi, A. and Nunn, H. *Reality TV: Realism and Revelation*, London, Wallflower Press, 2005

Branston, G. and Stafford, R. *The Media Student's Book*, London, Routledge, 1996

Branston, G. 'Understanding Genre', in *Analysing Media Texts Book 4*, *Understanding Media DA204*, Milton Keynes, Open University, 2006

Burrell, I. 'Is Reality Television too Risky for the Brittle Egos of Celebrities?', *The Independent*, 7 May 2003

Busfield, S. 'Britain's Got Talent Results Show Draws Peak of More than 19m Viewers', *The Guardian*, 1 June 2009

Carson, B and Llewellyn-Jones, M. (eds) *Frames and Fictions on Television: The Problem of Identity within Drama*, Bristol, Intellect Books, 2001

Caughie, J. 'Progressive Television and Documentary Drama' *Screen* vol. 21, no. 3, 1980, p. 30

Cohen, S. *Folk Devils and Moral Panics*, London, MacGibbon and Kee, 1972

Coles, G. 'Docusoap: Actuality and the Serial Format', in Carson and Llewellyn-Jones *Frames and Fictions on Television: The Problem of Identity Within Drama*, Bristol, Intellect Books, 2001

Collins, M. 'Truth to Tell', *The Observer*, 6 February 2000

Connell, B. (ed.) *Exploring the Media; Text, Industry, Audience*, Leighton Buzzard, Auteur, 2008

Corner, J. 'Documentary Voices', in *Popular Television in Britain*, ed. Corner, London, BFI, 1991

Couldry, N. *The Place of Media Power: Pilgrims and Witnesses of the Media Age*, London, Routledge, 2000

Couldry, N. 'Teaching Us to Fake It: The Ritualized Norms of Television's "Reality" Games', in Murray, S. and Ouellette, L. (eds) *Reality TV: Remaking Television Culture*, New York, New York University Press, 2004: 57–74

Dixon, S. 'Product Placing Allowed on TV', *Sunday Times*, 13 September 2009

Duncan, B. *Mass Media and Popular Culture*, Canada, Harbourt Brace Jovanovich, 1988

Dunkley, C. 'It's Not New and it's Not Clever', *Institute of Ideas*, 2002: 35–46

Evans, J. and Hesmondhalgh, D. *Understanding Media: Inside Celebrity*, Maidenhead, Open University Press/Open University, 2006

Fiske, J. and Hartley, J. *Reading Television*, London, Methuen, 1978 (reprinted 1987)

Fiske, J. *Television Culture*, London, Methuen, 1987

Foucault, M. *Discipline and Punish*, London, Harmondsworth, Penguin, 1980

Gillespie, M. (ed.) *Media Audiences*, Maidenhead, Open University Press/Open University, 2006

Goldsmith, B. 'The Meaning of Celebrity', *New York Times*, 1986 (in Duncan, 1988)

Goodwin, D. *The Guardian*, 25 July 2001 (quoted in Armstrong, R. 2005)

Habermas, J. 'The Public Sphere an Encyclopaedia Article', in S. Brunner and D. Kellner (eds) *Critical Theory and Society*, London, Routledge, 1989

Helsby, W. et al *Understanding Representation*, London, BFI, 2005

Hill, A. '*Big Brother*, the Real Audience', *Television & New Media*, vol. 3, no. 3, pp. 32–40, 2002

Hill, A. 'Reality TV', 2004, in Gillespie, M. *Media Audiences*, Milton Keynes, Open University, 2006

Hill, A. *Reality TV: Audiences and Popular Factual Television*, London, Routledge, 2005

Keighron, P. 'Video Diaries: What's up Doc?' *Sight and Sound*, no.10, 1993

Keighron, P. 'TV's Altered Realities', *Broadcast*, 6 June 2003

Kilborn, R. and Izod, J. *An Introduction to Television Documentary, Confronting Reality*, Manchester, Manchester University Press, 1997

Lakshman, N. 'Viacom Conquers India via Reality TV', *Business Week Online*, 10 February 2009

Lawson, M. 'An Original of the Species', *The Independent*, 10 February 1993

Mathijs, E. and Jones, J. *Big Brother International. Formats, Critics and Publics*, London, Wallflower Press, 2004

McLuhan, M. *Understanding Media: The Extensions of Man*, New York, McGraw-Hill, 1964

McQueen, D. *Television*, London, Arnold, 1998

Muir, S. *Documentary: The Voice of God or Fly on the Wall*, London, BFI Media Studies Conference, 2003

Nichols, B. 'Documentary Theory and Practice', *Screen*, vol. 17, 1976

Nichols, B. *Representing Reality: Issues and Concepts in Documentary*, Bloomington and Indianapolis, Indiana University Press, 1991

Ogle, T. 'So You Want to be a Docu-soap Star..?', *Radio Times*, 31 January–6 February 1998

Paton, G. '*Big Brother* "distorts reality for children"', *The Daily Telegraph*, 16 June 2009

Paton, G. 'Tears, fears – and now children may be banned from reality TV', *The Daily*

Bibliography

Telegraph, 15 December 2009

Points, J. 'The Real Thing', *Media Magazine*, February 2004, London, English and Media Centre

Raynor, P. Wall, P. and Kruger, S. *Media Studies: The Essential Resource*, London, Routledge, 2004

Sabbagh, D. and Sherwin, A. 'After Eight Years of Upsets, *Big Brother* is to be Toned Down', *The Times*, 27 January 2007

Seymour. M. 'I Starred in a Reality TV Show', *BBC North Yorkshire*, 27 January 2008, accessed 27/02/2009

Sparks, C. 'Reality TV: the *Big Brother* Phenomenon', *International Socialism*, no. 114, on www.isi.org.uk/index, accessed 22/06/09

Stewert, C., Lavelle, M. and Kowaltzke *Media and Meaning: An Introduction*, London, BFI, 2001

Turner, G. *M/c Journal* 7(5), 2004

Walters, B. 'People Appeal', pp9-11 *Sight and Sound Media Briefing*, London, BFI, 2002: 9–11

Wilcock, J. *Documentaries: A Teacher's Guide*, Leighton Buzzard, Auteur, 2000

BFI Education Projects Development Unit, *Television Documentaries Education Resource Pack*, London, BFI, 2000

Wilson, G. 'Fly-on-the-wall Documentaries', *Saturday Express Magazine*, 7 February 1998

Wren, C. 'Get Real. Eat Maggots! Survivor', *Commonweal* 127(14), 11 August 2000, p. 18

Websites

www.filmeducation.org – for film documentary resources

www.screenonline.org – for resources on British film and television with short video clips and teaching resources on documentary and reality TV including: drama-documentary; fly-on-the-wall TV (*Police* [1982], *The Office* [2001–3], *Faking It* [2000–5], *Vets in Practice* [1997–2002], *Driving School* [1997], *The Family* [1974], *I'm a Celebrity…Get Me Out of Here!* [2002–])

www.beonscreen.com – for reality show auditions and audiences

www.camcentral.com – an umbrella site for camcorder locations

www.barb.co.uk – official statistical site: gives viewing figures on channels such as Discovery Real Time; UKTV Style and Zone Reality

www.bbc.co.uk – public service broadcaster, especially useful is the commissioning site for audiences

www.ofcom.org.uk – regulator for commercial broadcaster

www.bfi.org.uk/filmtvinfo/publications/16+/pdf/docusoappdf a source guide for a list of resources held by the BFI Library

www.DreamislandTVproduction.com search on 'Reality TV' a company organising a reality show with participants on an island with a Big Chief (instead of Big Brother)

www.starnow.co.uk/Casting-Calls/Reality-TV/ for opportunities to go on shows like make-overs

www.wikipedia.org/wiki/Reality_television - the encyclopaedia site which has information on history, types and criticisms mainly from the US angle. Be warned the articles are not authored so to be treated with circumspection

www.uk.zonereality.tv/ 'Zone Reality is the only TV channel dedicated to showing reality programming 24 hours a day, 7 days a week'

www.guardian.co.uk/media/ newspaper site with informed articles

www.tv-ark.org.uk – a source of historical items connected with television including clips of programmes.

www.channel4.co.uk/bigbrother -the channel and programme's web site

www.mediaknowall.com – general Media Studies website aimed at GCSE and A level students.

www.youtube.com - for extracts from shows

Other Resources

Channel 4, *How TV Changed Britain*, 8 June 2008

The Truman Show, (Peter Weir, 1998) – Truman Burbank learns his whole life is being filmed and orchestrated for the benefit of a global reality TV show

Live! (Bill Guttentag, 2007) – LA producer is filmed by a documentary crew as she puts a Russian roulette game show live on air

Andy Hamilton, Huw Weldon Memorial Lecture (1998)

The Great Reality TV Swindle, Channel 4, December 2002

Series 7: The Contenders (Daniel Minahan, 2001) N.B. cert 18 – marketed in the UK as 'Big Brother with Bullets'. In America it was 'Real People in Real Danger', a reality show set in America where the contestants' objective is to kill the others to win fame and freedom

The Office (BBC, available on DVD)

Docusoaps and Reality TV, 16+ source guides, bfi National Library (2000) – a list of books, journal articles and press articles with short synopses with resources on case studies on *Sylvania Waters*; *Big Brother* Series 1 and 2; *Popstars* and *Driving School*